IMAGES
of America

BUILDING THE MASS PIKE

Yanni K. Tsipis

ARCADIA

Copyright © 2002 by Yanni K. Tsipis.
ISBN 0-7385-0972-8

First printed in 2002.

Published by Arcadia Publishing,
an imprint of Tempus Publishing, Inc.
2A Cumberland Street
Charleston, SC 29401

Printed in Great Britain.

Library of Congress Catalog Card Number: 2001096129

For all general information contact Arcadia Publishing at:
Telephone 843-853-2070
Fax 843-853-0044
E-Mail sales@arcadiapublishing.com

For customer service and orders:
Toll-Free 1-888-313-2665

Visit us on the internet at http://www.arcadiapublishing.com

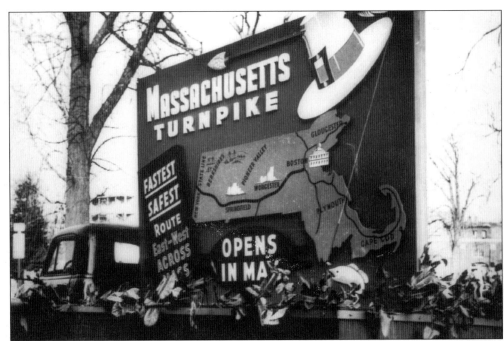

In preparation for the opening of the initial turnpike, the Massachusetts Turnpike Authority launched a widespread publicity campaign to tout the benefits of the new road. From a modern standpoint, this invitation to congestion seems counterintuitive. The Massachusetts Turnpike Authority, however, relied on high traffic volumes to produce revenues sufficient to pay off its $239 million in bonds.

CONTENTS

ACKNOWLEDGMENTS

Condensing the history of one of the state's greatest public works projects into this slim volume was a task made possible only by the generous and invaluable contributions of the following individuals: Robert Bliss, J. Richard Capka, Joseph Landolfi, and Renford Taylor at the Massachusetts Turnpike Authority; Martin DeMatteo at DeMatteo Construction; John Driscoll; Megan Dumm and Amy Sutton at Arcadia Publishing; Paul Kavanaugh at the Perini Corporation; Elisabeth Kehrer for her grammatical expertise; Ken Kruckemeyer and Fred Salvucci at the MIT Center for Transportation Studies; Aaron Schmidt at the Boston Public Library's Prints Department; and MIT Department of Urban Studies and Planning professor Robert Fogelson, who sparked my interest in the turnpike.

Once again, I would like to give special thanks to George Sanborn at the State Transportation Library for his unceasing generosity and assistance with this project.

—Yanni K. Tsipis
Massachusetts Institute of Technology
Cambridge, Massachusetts

FOREWORD

The idea for this book came out of a meeting between the author and two officials at the Massachusetts Turnpike Authority—director of communications Robert Bliss and chief of staff Joe Landolfi. An offhand remark soon grew into plans for this account of the construction of the largest public works project in the history of the Commonwealth. Although the 135-mile turnpike has played a central role in reshaping the state physically and economically for nearly four decades, passing references in survey texts have had to suffice for those interested in its history.

The legacy of the turnpike's construction is being felt more strongly today than ever before, as metropolitan Boston bears the costs and reaps the benefits of a massive project born of lessons first learned half a century ago. That legacy is largely the result of one man and the highway system to which he devoted three decades of his life—William F. Callahan, commissioner of the Massachusetts Department of Public Works and chairman of the Massachusetts Turnpike Authority for the first 12 years of its existence.

Callahan perceived earlier than most transportation planners in this country that highway projects could accomplish more than simply relieving traffic; they could enable more efficient transportation of goods and people, generate economic growth, and dramatically affect land-use patterns. With that idea in mind, Callahan (beginning in the early 1930s with an embryonic Route 128) undertook a highway-construction program that would prove to be decades ahead of its time.

The highway program—overseen by Callahan while commissioner of the state department of public works and later at the helm of the Massachusetts Turnpike Authority—yielded a mixed bag of results. As the new highways completely reshaped the Boston metropolitan region, economic growth and prosperity were accompanied by increasingly sprawling land-use patterns and wrenching personal upheaval for thousands. In the end, Callahan's road network enabled a desperately needed statewide economic realignment but left communities and neighborhoods throughout the Commonwealth bearing the scars of regional progress.

The myriad effects of Callahan's highways strongly reinforced the notion he so fervently championed that highway projects were about much more than just moving cars and trucks. A decade after Callahan's death, that same principle led a small group of farsighted planners to set in motion the process that culminated in the current Central Artery/Third Harbor Tunnel project. Today, the city is in the midst of one of the greatest pubic works projects undertaken in the modern age, a project that has yielded tremendous regional and local economic benefits and will reshape the city of Boston forever.

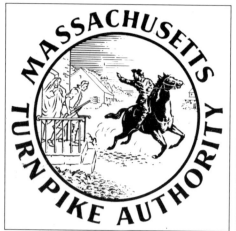

To the left is the original seal of the Massachusetts Turnpike Authority from its charter in 1952. The seal depicts Paul Revere's ride through the city's northwestern suburbs in 1775. In the spring of 1956, it gave way to the ubiquitous arrow-pierced Pilgrim's hat, shown to the right. The arrow disappeared in 1990.

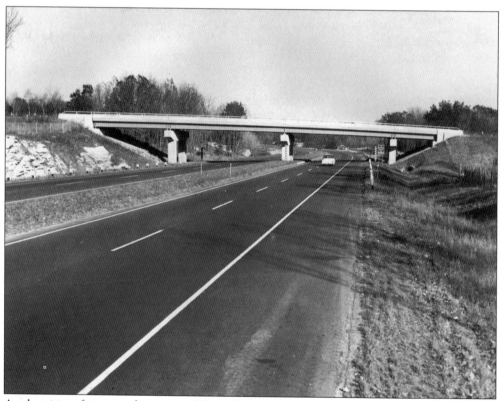

At the time of its completion in 1957, Callahan's 123-mile turnpike was nothing short of revolutionary in a state where the existing east-west road network dated back to the days of the Model T in places. A trip across the state by car or truck in 1950 could easily take more than four hours. On the new turnpike, it took two.

One

BEFORE THE TURNPIKE

*The pride which a Bostonian . . . feels in his city is based upon its
past history, its actual condition and its future prospects.*
—Mayor Frederic Lincoln, September 1866

In the spring of 1952, neither Boston's actual condition nor its future prospects especially impressed William Callahan. From his fourth-floor window on Nashua Street near North Station, the commissioner of the Massachusetts Department of Public Works had a commanding view of the city—and therein lay the problem. In an age when other large American cities sported dozens of high-rise office towers, Callahan could see clear across the city from his window with little more than the 1915 Custom House tower to block his view.

Boston's unimpressive skyline was indicative of the economic condition of the old city. Its once bustling waterfront had fallen into decay in the few years since the close of World War II; its downtown financial district had barely seen new construction since the pre-Depression era; and the city's industries were choking on a regional transportation network that had been in decline since the 1920s. To make matters worse, Callahan—a keen observer of regional transportation trends—was well aware of the rapidly deteriorating fiscal health of the region's major railroads. In addition, he could not ignore the planning of the St. Lawrence Seaway, which would allow Midwestern products to be shipped by sea directly from Great Lakes ports, bypassing the port that had once all but cornered that market. Most distressing of all to the commissioner was the explosive postwar growth in private automobile ownership and intercity truck transportation. As the Commonwealth's chief road builder, he knew firsthand how ill-equipped the state's existing road network was to handle the additional traffic.

The last major highway project completed by the Massachusetts Department of Public Works before the Depression and World War II intervened was Route 9, also known as the Worcester Turnpike. The road stretched west from Huntington Avenue in Boston and passed through the city's western suburbs on its way to Worcester. Studded with at-grade intersections, low overpasses, and tight curves between Boston and Worcester, the once modern highway had grown hopelessly obsolete by 1950. Furthermore, Route 9 west of Worcester reverted to an alignment and design standard dating from the turn of the century. The state's other east-west

routes found themselves in a similarly deplorable condition, and the toll that condition was taking on the Commonwealth's capital city was unmistakable.

Boston had long been a city dependent on its regional transportation network to feed its industries with raw materials and to keep its docks bustling. The long decline of its railway and road network had contributed greatly to the city's mounting troubles in the immediate postwar years. The city had not seen a building boom since the first half of the 1920s. By 1950, its once bustling waterfront had largely fallen into dormancy. The city's prohibitively high property taxes (coupled with large tracts of cheap suburban land along the nearly completed Route 128) drove many newer industrial and commercial interests into the suburbs. A less tangible but equally important force was also driving that early trend toward suburbanization, caused by a rapid and dramatic shift in the region's economy. By the early 1950s, the metropolitan Boston area was experiencing rapid employment growth in the technology sector. Employers found many of these workers eager to adopt a suburban lifestyle centered around the automobile. With access to downtown limited by a congested street system, employers balked at locating in traditional downtown locations. Not until better roads led to Boston's downtown core could the city take advantage of the explosive regional growth in white-collar employment. In the meantime, the Custom House tower would continue to cast the only shadow across downtown streets.

The economic malaise that had befallen the city of Boston was not confined to its boundaries. A sharp postwar decline in the health of the state's traditional manufacturing sectors was especially pronounced in the larger industrial cities of Framingham, Worcester, and Springfield. Remaining industries found that their close proximity to spurs of the region's dense rail network had ceased to offer any competitive advantage over industries in other parts of the country. By 1950, convenient access to good road transportation mattered far more than proximity to railways to all but the highest-volume industries. This was especially true for manufacturers of high-value, low-volume goods like electronics, as railroad freight rates were often based on a product's dollar value rather than on its weight. In order for the state's traditional industrial hubs to take advantage of the postwar boom in the electronics industry, they too needed easy access to a modern regional road network.

The postwar plights of the Commonwealth and its capital city had many origins, but none eclipsed the desperate need for an improved regional transportation network linking together the state's largest cities and the downtowns of those cities to their suburbs. National trends in car ownership and truck transport left transportation planners who sought to address that need with little alternative but to exercise solutions based on rubber rather than steel wheels. The hastily generated highway plans of those early postwar years would soon lead to a dramatic physical and economic transformation of the Commonwealth, and especially of its capital city. The following images depict scenes of a state and its capital that had fallen behind the economic times and were about catch up at a breakneck pace.

In the spring of 1955, this stately home in Weston fell victim to the turnpike's construction. The alignment of the initial turnpike ran almost exclusively through low-density communities in the interest of minimizing the cost of property takings. At the expense of convenience, William Callahan deliberately avoided running the turnpike directly through the major metropolitan areas west of Boston.

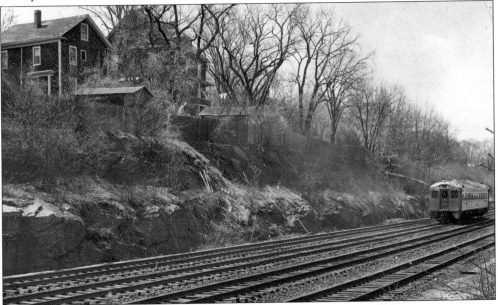

This view of the southern side of the old Boston & Albany corridor in West Newton gives a good sense of the scale of development along the railroad's southern flank prior to turnpike construction. Single-family homes (all taken down to make way for the highway) stand atop the shallow bluff overlooking the tracks. To the right, a lone Budd car makes its way west.

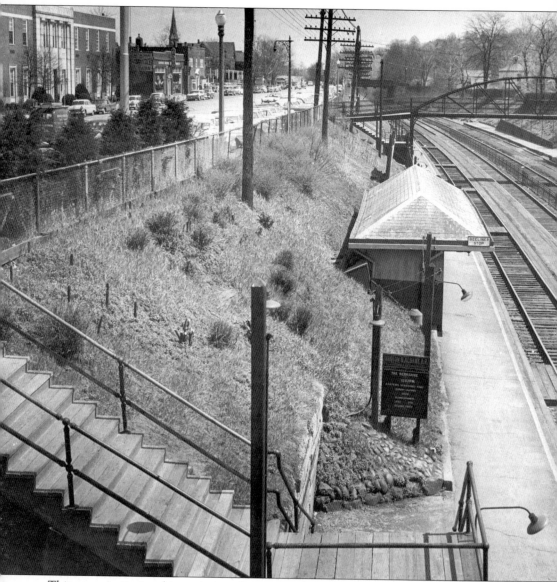

This panoramic view (a composite of two images) shows Washington Street (left) and the old Boston & Albany Newtonville depot (right). The construction of the Newtonville depot predated the 1895 grade separation of the Boston & Albany tracks, and the original granite block foundation and waiting platform is visible behind and above the more recent platform. The grade modification left the main entrance to the station on Bowers Street (extreme right) but produced an oddly sloping platform roof and rather awkward trackside access. The station

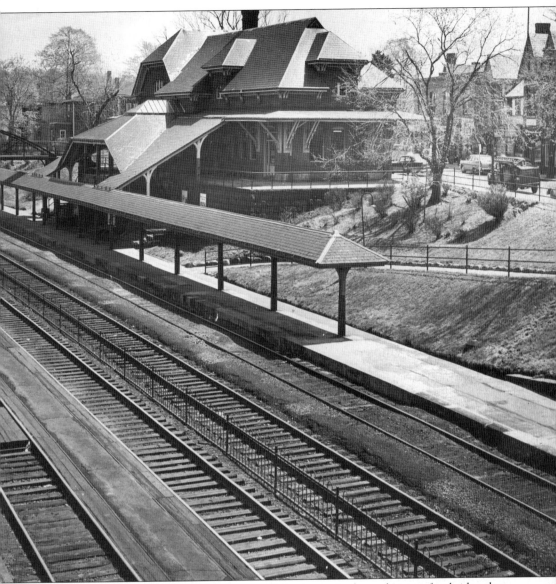

was demolished in the fall of 1962. At the top of the image is the pedestrian footbridge that carried inbound passengers from Washington Street over the tracks. All the depots along the Boston & Albany line through Newton were constructed on the inbound side of the tracks to accommodate morning commuters. Few commuted outbound, and only a small waiting area was provided on that side of the line.

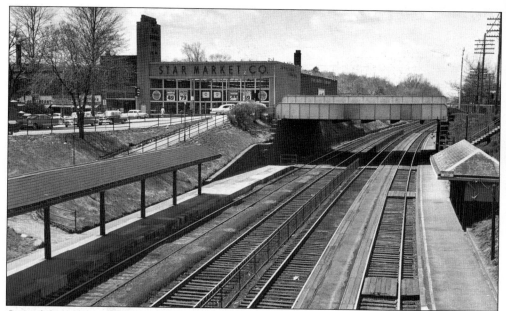

One of the largest structures in the city of Newton to be demolished by the turnpike work was the Star Market at the corner of Austin and Walnut Streets in Newtonville. This view looks west from the pedestrian overpass at Newtonville station at the old market. Callahan allowed Star to rebuild over the new turnpike, making the new market and the Prudential Center the state's first air-rights projects.

Newton Corner is seen in the summer of 1958 from the Richardson Street bridge. Just to the left of the Boston & Albany corridor is the old Newton fire station No. 1, built in 1929. The structure would be demolished by turnpike construction, but Newton mayor Donald Gibbs secured $250,000 from the Massachusetts Turnpike Authority to build a new station.

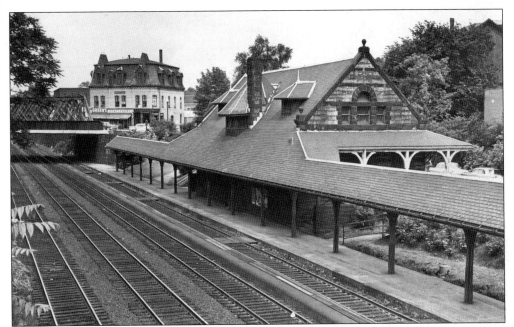

Here is another example of the architectural effects of the grade separation project on Newton station, built in the early 1880s near the intersection of Center Avenue and Center Street. Beyond the station is the old Center Street truss bridge and Bay State Hall. Every structure in this image would come down in 1962 to make way for the Newton Corner interchange.

This 1958 view looks west from the Washington Street bridge in Newton Corner toward the old Center Street steel-truss span in the background. Nothing from this view survived the turnpike's extension through Newton; the area became the Newton Corner interchange and was altered beyond recognition.

Looking northwest over the Washington Street bridge in Newton Corner, this view shows a PCC streetcar making its way toward its next stop at Oak Square, Brighton. The Turnpike Authority paid to replace the tracks it tore out of the old bridge, but streetcar service ceased only five years later, in 1969.

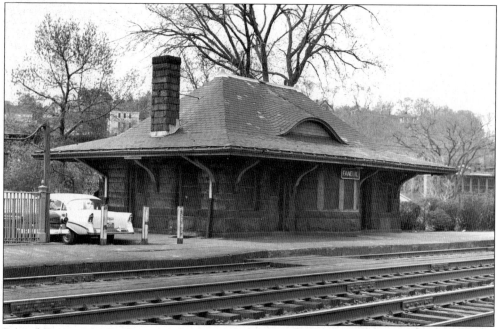

Faneuil Station, in Brighton, is shown in the spring of 1958. Built in the early 1880s near Brooks Street, Faneuil Station was the city's first true intermodal transit facility. Never before in Boston had a bus line served a commuter rail station. In 1922, however, the Boston Elevated Railway replaced a steel-wheel streetcar line serving the station from Oak Square with its first rubber-tire bus route.

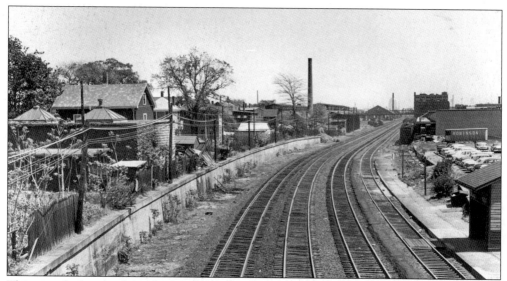

This view looks east from the Market Street bridge in the spring of 1958. The homes along Lincoln Street (left) would all be demolished to make way for the turnpike. The property at 25–27 Lincoln Street (with the large tree in the backyard) belonged to Stefano and Louisa Gentile, grandparents of future Massachusetts secretary of transportation Fred Salvucci.

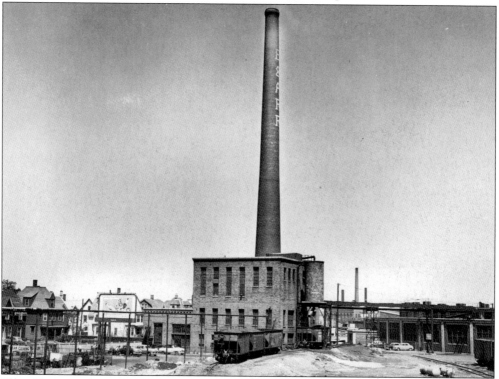

The old steam plant of the Beacon Park rail yards was built c. 1900 and was modernized in 1930. Note the "B&ARR" inlaid in the brick smokestack and the close proximity of the residential neighborhood along Cambridge Street to the left. To the right is one of the two old roundhouses at Beacon Park yards, both replaced with turnpike ramps.

Pictured is the old intersection of Commonwealth Avenue and Essex Street near the Boston University bridge. At this point, several major traffic routes intersected with each other and with streetcar lines in the median of Commonwealth Avenue, creating one of the city's most dangerous and congested intersections. The construction of the turnpike dramatically changed the traffic pattern in this area.

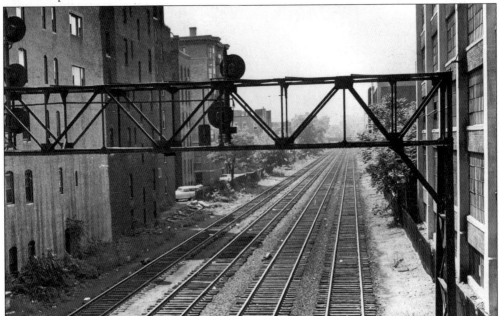

This view looks west from the old Beacon Street bridge in the spring of 1958. To the left is a series of brick apartment buildings fronting on Mountfort Street, dating to the 1890s and demolished in the fall of 1962. The original Boston & Worcester railroad was completed in 1835 and became the Boston & Albany in 1867. In the early 1880s, the railroad widened the original two-track right-of-way through Boston to the four tracks seen here.

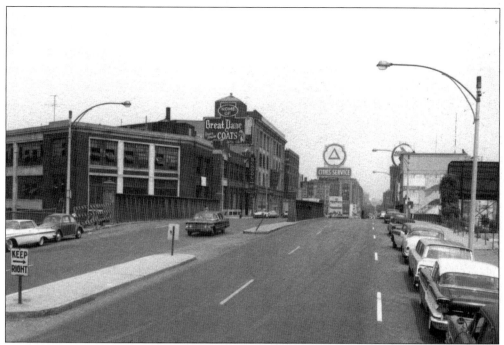

Looking over the old Beacon Street bridge toward Kenmore Square, this 1963 view shows a series industrial loft buildings (left) that were completed in 1916.

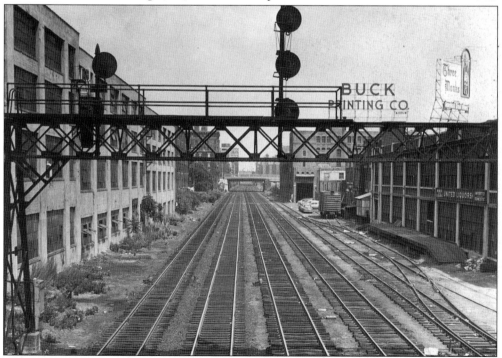

This view looks east from Brookline Avenue with Lansdowne Street at right and rows of warehouse and industrial loft buildings along Newbury Street at left. These structures would come down in 1963 in order to widen the existing Boston & Albany right-of-way.

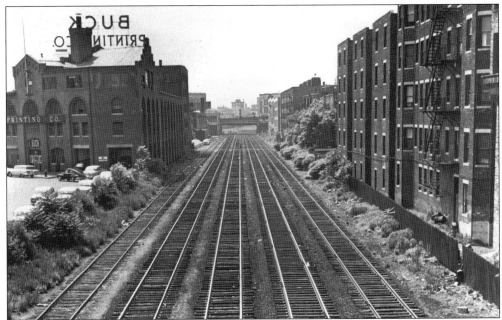

To the right in this view, looking west from the old Charlesgate overpass, are densely packed apartment buildings along the south side of Newbury Street behind Kenmore Square. To the left is the Buck Printing Company, located on the corner of Lansdowne and Ipswich Streets. The track to the far left is a freight siding, serving warehouses farther west along Lansdowne Street.

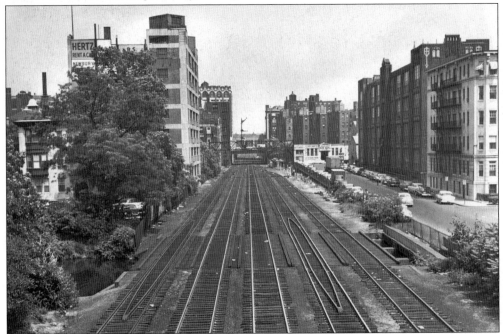

This view was taken in the summer of 1958 from the Charlesgate bridge, just east of Kenmore Square. Massachusetts Avenue is in the distance, and the Muddy River flows under the Boston & Albany tracks in the foreground. The seven-story Newbury Garage (left), completed in 1927, came down in the spring of 1963 to make way for the turnpike.

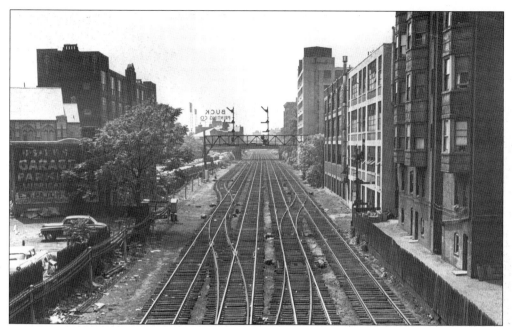

Looking west from Massachusetts Avenue in 1958, this view shows apartment and industrial loft buildings on Newbury Street (right), along the north side of the rail corridor. These buildings were all taken down as part of the turnpike construction. The Fenway loft building (left) still stands today.

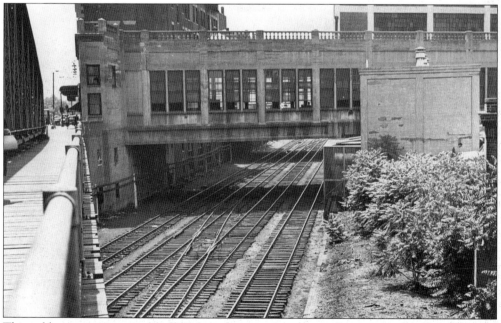

This odd arrangement is the old Massachusetts Avenue streetcar station at the corner of Boylston Street, built in 1918. To the right is the side of the old Boylston Street bridge. Clearly visible is the block of commercial structures that once occupied the corner lot at the intersection with Massachusetts Avenue. The streetcar station, commercial block, and bridge all came down in 1963 to make way for the eight-lane turnpike.

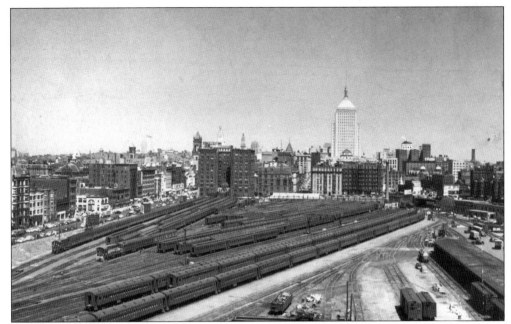

The Boston & Albany Railroad's Back Bay (officially, Dartmouth Street) yards are shown prior to the construction of the Prudential Center and the turnpike. Boylston Street is to the far left. The path of the turnpike would run from the lower left corner to the far right corner of the yards. (Courtesy Boston Public Library, Prints Department.)

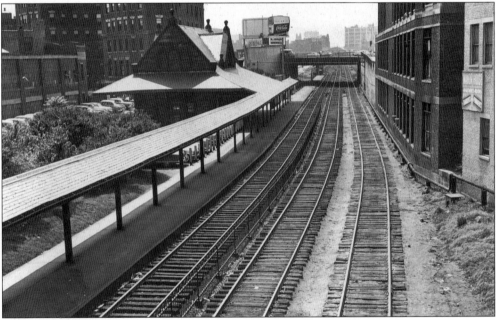

This view looks west from Dartmouth Street past the Boston & Albany's Huntington station, completed in 1899. Both the Huntington depot and the neighboring Trinity Place station were designed by A.W. Longfellow, who worked under H.H. Richardson from 1882 to 1886. Behind the station's cornice are the studio buildings at 20–30 St. Botolph Street; the demolition of these buildings sparked especially intense controversy.

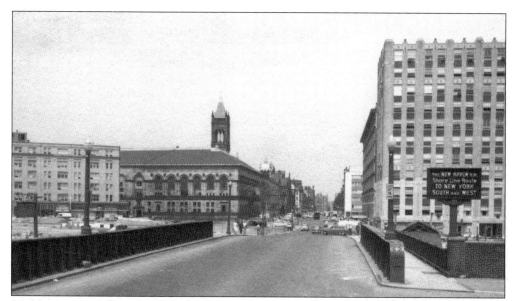

Looking north up Dartmouth Street from in front of Back Bay station, this photograph shows the Boston Public Library (left), today obscured by the Westin Hotel on the opposite side of Dartmouth Street. The sign to the right indicates the point at which the New Haven Railroad's Shore Line meets the Boston & Albany corridor.

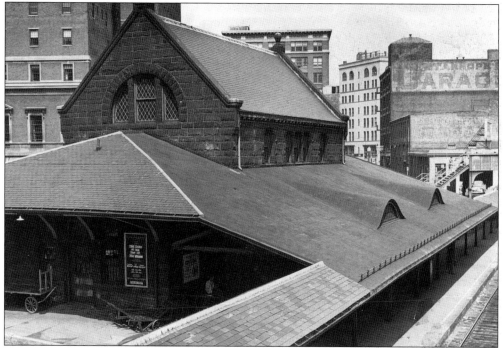

Pictured is the Trinity Place station, located diagonally across Dartmouth Street from the Huntington station and across the tracks from the New York, New Haven, and Hartford Railroad's Back Bay station. The demolition of this station was postponed until late February 1964 to allow scenes for the movie *The Cardinal* to be filmed there. The Stanhope Garage and other buildings to the right all came down in 1963.

As far as the eye can see in this view looking northeast over the Tremont Street bridge, buildings came down to make way for the turnpike. Today, this area is the site of the Mass Pike Towers housing development, built along Marginal Road just north of the turnpike corridor.

One of the city's busiest streetcar lines once ran down Tremont Street through Roxbury Crossing into Egleston Square. Service along the line ceased in November 1961, but the tracks remained in the street even after the overhead trolley wires came down. This photograph looks south over the Tremont Street bridge toward the old Castle Square neighborhood. At the center is the old Norris Piano workshop.

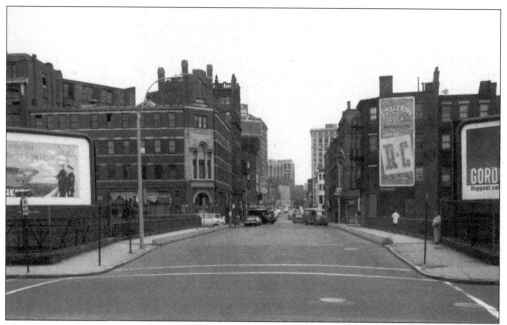

This view looks north over the old Shawmut Avenue bridge. The buildings lining Corning Street on the far side of the bridge would all fall victim to turnpike construction beginning in the fall of 1962. The Royal Crown Cola Company lost much more than just the billboard to the right—its old bottling plant in Newton Corner was also taken down during the turnpike work.

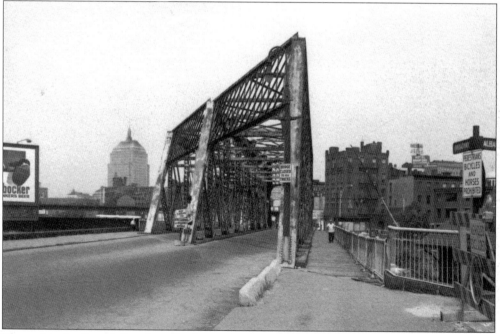

The uniquely shaped Broadway bridge is shown in a view looking west from the corner of Albany Street and Broadway. This bridge was built c. 1890. The city agreed to abandon the bridge in 1963 and saved William Callahan the considerable expense of reconstruction. Note the sign to the far right prohibiting horse traffic!

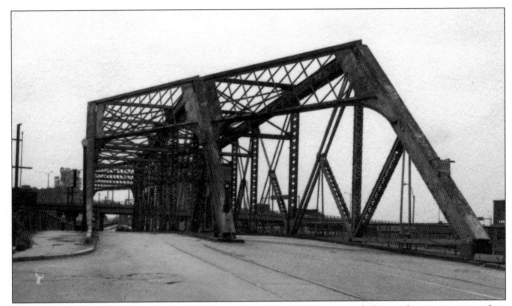

This view of the Broadway bridge looks east into South Boston and shows the intricacies of its steel-truss design. Tracks of the Metropolitan Transit Authority's City Point–North Station streetcar line are visible in the street, but the service had ceased in December 1953.

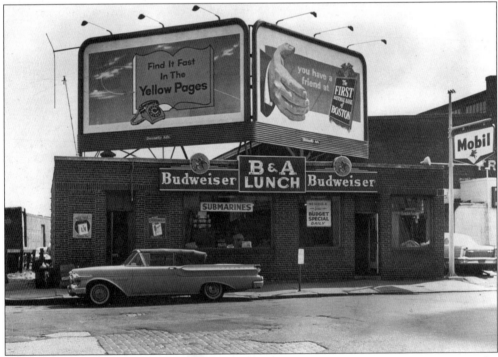

The B & A diner was located on the corner of Kneeland Street and Atlantic Avenue near the current TriGen steam plant. Although this little building survived the turnpike construction, few of its neighbors were so lucky. Note the old cobblestones in Kneeland Street below the crumbling pavement—quite the metaphor for the city's major thoroughfares before the construction of the Central Artery and turnpike extension.

Two

THE INITIAL TURNPIKE

The present east-west interstate highway between the metropolitan area of Boston and the New York State Line . . . is obsolete, inadequate, deficient, and outmoded.
—From *Trans-State East-West Toll Road Study*
Massachusetts Department of Public Works, February 1952

Few in the Commonwealth doubted the urgent need for a modern express highway linking its capital city with the rest of the state. The existing roads were taking a heavy toll in lives and on commercial activity from Boston to Pittsfield. The greatest problem facing the many proponents of the new expressway was its estimated price tag. At more than $150 million, it represented a massive capital expenditure the state was ill-prepared to make. Since 1949, when newly elected Gov. Paul Dever reinstated William Callahan at the helm of the Massachusetts Department of Public Works, the legislature had authorized nearly $400 million in bond issues for an ambitious slate of highway projects laid out in the state's 1948 Highway Master Plan. The slate of state-funded projects included the Central Artery, Southeast Expressway, Storrow Drive, and Route 128. However, as the price of hacking through the city for the Central Artery rose from $30 to $110 million, an increasing share of the state highway money stayed in Boston and caused a growing fraction of the state legislature to balk at funding additional projects. With the state's bonding capacity strained and a public tax burden already generating widespread discontent, it was clear to proponents of the east-west expressway that the state would not be paying for it, either with a bond or by direct appropriation.

The solution came from the man who had been building roads in Massachusetts for nearly two decades. Recognizing the scope of the constituency clamoring for the new expressway, William Callahan proposed the creation of an independent, semipublic authority to undertake its financing, construction, and operation. The authority model had been perfected in the 1930s by New York's Robert Moses. By 1952, toll road authorities in six northeastern states had built 621 miles of expressways. By the middle of the year, a seventh (in Massachusetts) would be planning 123 miles of its own, with Callahan leading the effort.

William Callahan, born in 1891 in the industrial town of Stoughton, began his engineering career as the stenographer of Boston's Eastern Dredging Company after completing high school. By the time he was appointed commissioner of the Massachusetts Department of Public Works

in 1934, Callahan had made a name for himself as a shrewd businessman and had served for 11 months as an associate public works commissioner specializing in marine matters. Callahan's first tenure at the helm of the Massachusetts Department of Public Works ended in 1939 when he tangled with newly elected Republican Gov. Leverett Saltonstall. Democrat Paul Dever reinstated him in January 1949 to oversee the massive postwar highway construction effort. It was during that second term in office that Callahan laid the political foundations for his plans to build a highway across the state. As the man overseeing the employment of thousands of workers on public works projects, Callahan tirelessly indulged the patronage requests of legislators of both parties. In return, he received the unwavering support of those he would one day rely upon to charter the Turnpike Authority and insulate it from political criticism as it matured.

The state legislature chartered the Massachusetts Turnpike Authority in the spring of 1952, and Gov. Paul Dever summarily appointed Callahan to an eight-year term as its first chairman. Callahan borrowed heavily from the enabling act of Robert Moses's Triborough Bridge and Tunnel Authority when drafting the Turnpike Authority charter. He created for himself a position of complete control over all Turnpike Authority activities. The position suited him well. Famous for his disdain for bureaucratic red tape while at the helm of the department of public works, Callahan had struggled for years to push his highway initiatives through the state's political maze and into construction. Now, the seasoned road builder could avoid that maze altogether. No longer dependent on the state legislature or the governor for funding, Callahan was free to pursue the massive highway project on his own terms.

The ability of the Turnpike Authority to finance the toll road was based solely on the toll revenues it was projected to generate, independent of the shaky fiscal condition of the Commonwealth or its capital city. Callahan's traffic engineering consultants developed revenue forecasts robust enough to generate intense interest in the Turnpike Authority's bond offering, even at a low interest rate of just over three percent. When the bonds went to market on the morning of May 1, 1954, all $239 million had been spoken for by noon.

After letting contracts in the summer and fall of 1954, construction of the turnpike as far east as Route 128 began in January 1955. In order to speed the delivery of the new road, Callahan cut up the job into 33 construction contracts and awarded them to a variety of contractors. This arrangement ensured that the entire length of the 123-mile expressway would be under construction at once. Callahan had set forth a compressed schedule that often entailed contractors working around-the-clock to meet deadlines, but setbacks plagued the construction. A major hurricane struck in August 1955 and washed away significant portions of work in progress and many critical access roads leading to job sites. Tough field conditions led to frequent equipment breakdowns, and the most extensive blasting job in the history of the state took a heavy toll in workmen's lives. The logistical complexities of keeping 123 miles of roadway under construction at once through remote areas posed problems many of the turnpike's contractors had never before faced. Despite the delays and complexities, however, the overall schedule slipped only a few months, and the road opened in May 1957.

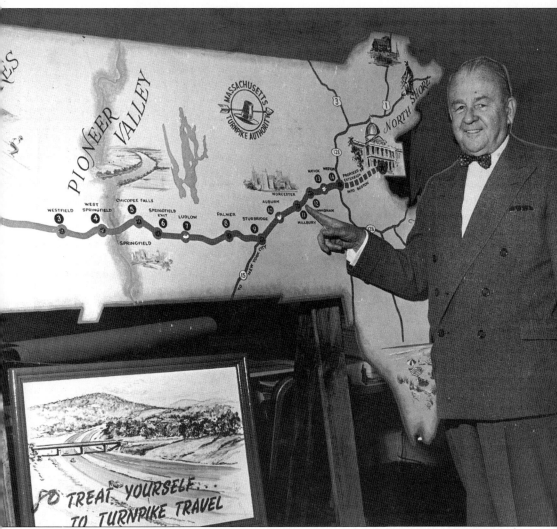

In this 1954 photograph, William Callahan may look happy pointing to the city of Worcester, but he deliberately bypassed the city and provided access by only two inconveniently placed interchanges. The Springfield area, by contrast, got four interchanges. Turnpike Authority vice chairman Benjamin Grout hailed from Springfield, and senior Democratic state representative (soon speaker of the house) John F. Thompson represented the neighboring town of Ludlow. Theories about the Worcester snub abound, but the construction of Interstate 290 and the recent opening of the Route 146 interchange in Millbury has dramatically improved access to the city. (Courtesy Boston Public Library, Prints Department.)

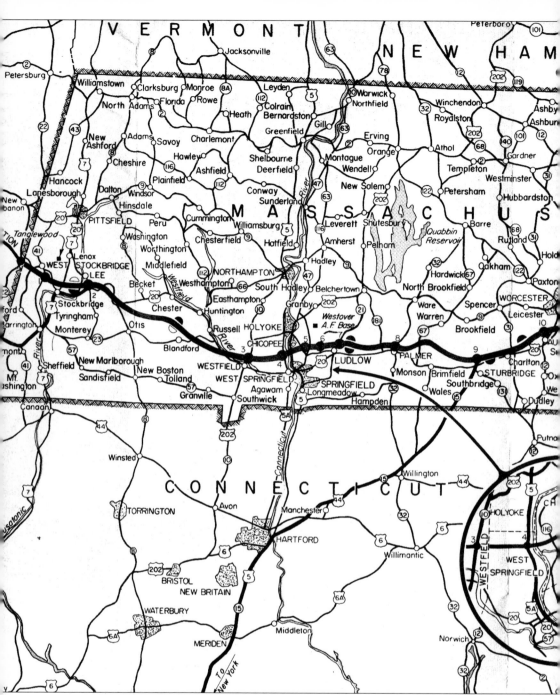

The initial turnpike, shown on this 1959 map, ran from the New York border to Route 128 in Weston. From that point, several local routes shown at the upper right provided the only access to downtown Boston. Prior to the construction of the turnpike, a trip to New York City from Boston would begin on the treacherous and congested Route 20 as far west as Sturbridge. For

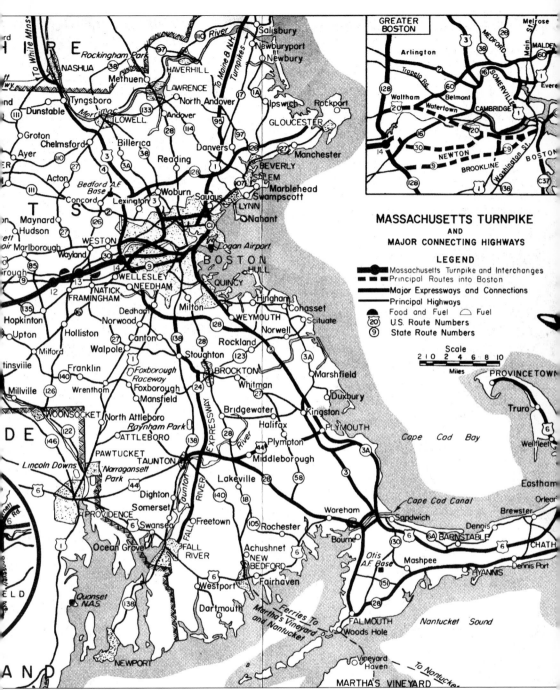

westbound motorists, the state of New York built a connection from the brand-new New York State Thruway to the turnpike's western terminus in West Stockbridge, enabling motorists to drive from Boston to Buffalo, stopping only to pay a toll. Within a few years, drivers could reach as far west as Chicago.

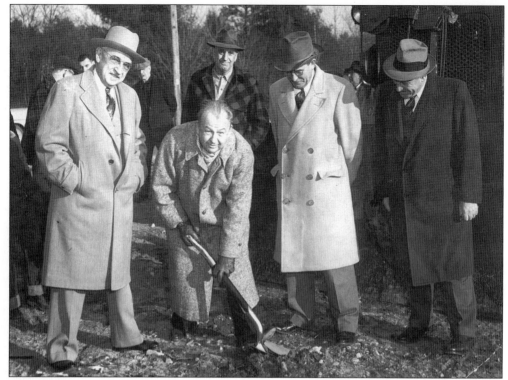

Seen at the groundbreaking ceremonies for the initial turnpike in the town of Wayland are, from left to right, Turnpike Authority vice chairman Benjamin Grout, chairman William Callahan (turning a spadeful of earth), chief engineer Philip Kitfield, and contractor Louis Perini. Begun in January 1955, the 123-mile turnpike took just over two years to complete. (Courtesy Boston Public Library, Prints Department.)

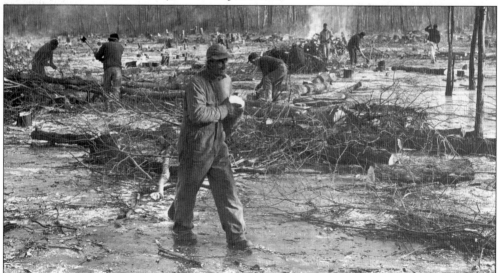

In the winter of 1955, workers are clearing the turnpike right-of-way through a forest with axes. Most of the road's 123-mile alignment west of Route 128 ran through wooded areas, and much of the clearing work was done by hand, as shown here.

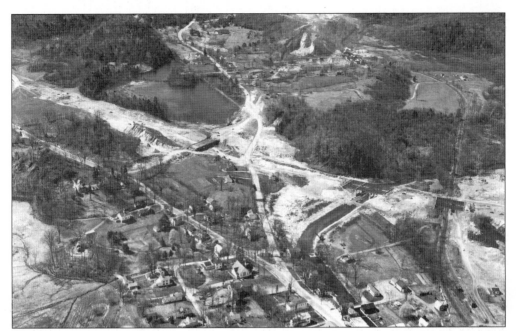

This aerial view looks south over the town of West Stockbridge at the turnpike's westernmost interchange near the New York border. The turnpike's path is clearly visible running across the center of the image, including bridges over local roads, the Williams River, and the State Line branch of the New York, New Haven, and Hartford Railroad's Housatonic line.

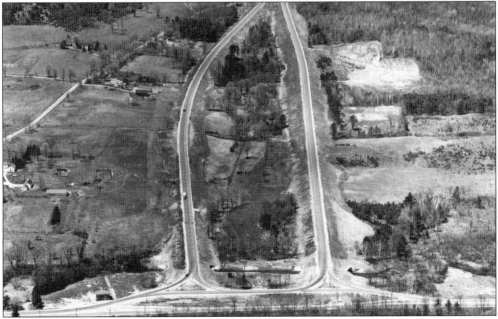

While still commissioner of the Massachusetts Department of Public Works, William Callahan undertook several large, state-funded projects designed to be incorporated into the turnpike he was planning behind the scenes. In this photograph, a previously completed section of Route 102 ends awkwardly in Stockbridge before linking up with the turnpike work and becoming part of the toll road.

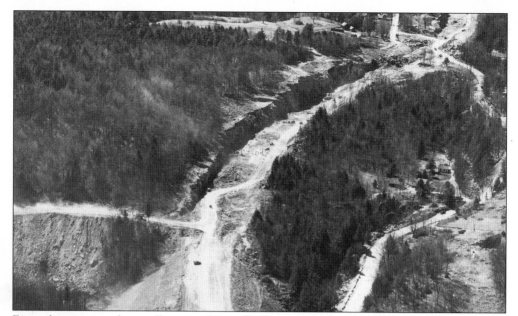

From the air over the small town of Russell, the magnitude of the earthmoving work that accompanied the turnpike's construction is visible. At the bottom of the image, a deep valley has been filled in to allow the roadway to pass through. Just beyond, the side of a large rocky hill has been blasted away to accommodate the roadway. It took 1.2 million pounds of dynamite to cut through the Berkshire foothills in this area.

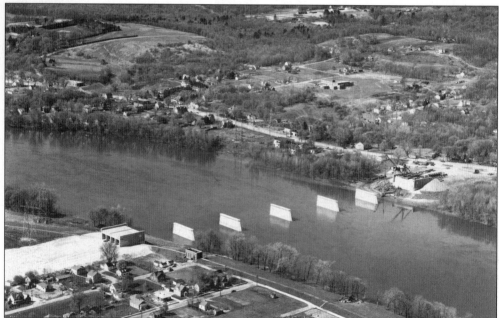

This image shows the beginnings of the Connecticut River crossing, the longest bridge on the initial turnpike. As early as 1952, William Callahan had the Massachusetts Department of Public Works begin work on the bridge while he was still chairman in order to get a head start on the turnpike work he was planning. Years later, as Turnpike Authority chairman, he reimbursed the state from turnpike funds.

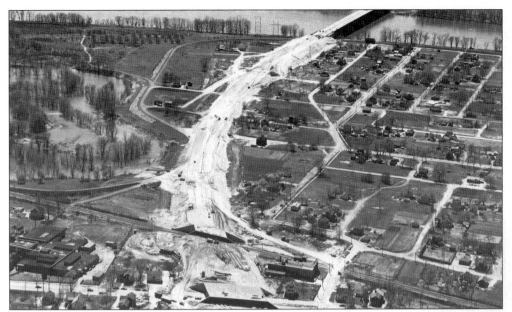

This view looks west toward the nearly completed Connecticut River crossing in Chicopee. In the foreground are underpasses for the Boston & Maine Railroad's Connecticut River line and Route 116. This was one of the most densely populated areas through which the initial turnpike passed, and right-of-way costs on the initial turnpike amounted to a paltry 6 percent of the total cost. When the road was extended through Boston, that figure climbed to 27 percent.

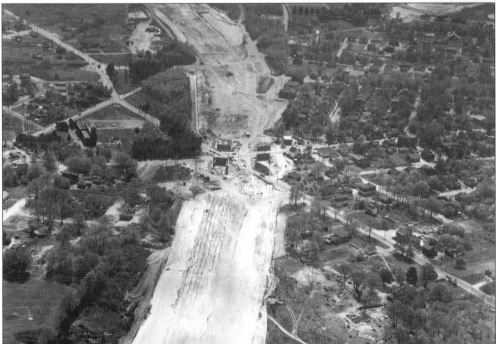

In this spring 1956 photograph, the turnpike cuts a broad path through the town of Chicopee, just west of Springfield. At the center of the image are the beginnings of a structure that will carry the turnpike over the intersection of Grattan and Granby Streets near Chicopee Falls.

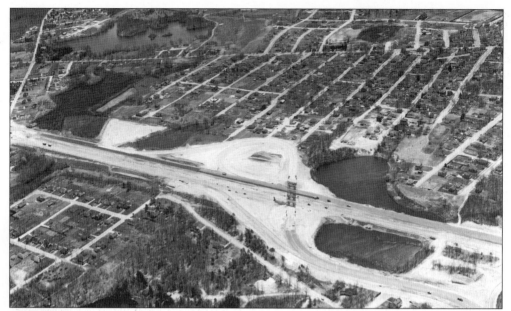

The nearly completed interchange in the town of Ludlow, a few miles east of Springfield, is shown in the spring of 1956. In this area, William Callahan had begun the relocation of nearby Route 20 by clearing the right-of-way and grading the new roadbed while still the public works commissioner. When he changed jobs, he purchased the half-completed new section of Route 20 from the state and incorporated it into the turnpike alignment.

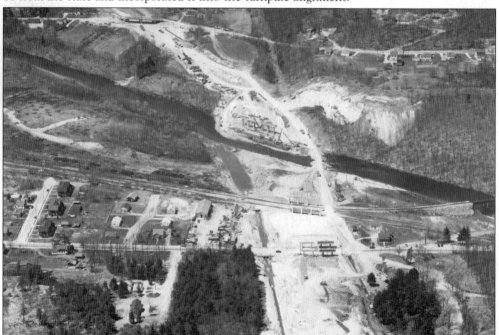

Four of the 185 bridges along the turnpike are shown in the town of Palmer. They are, from top to bottom, the Calkins Street bridge, the Quaboag River crossing, the Central Vermont Railroad underpass, and the Route 181 (Sykes Street) underpass. Note the old railroad bridge to the far right.

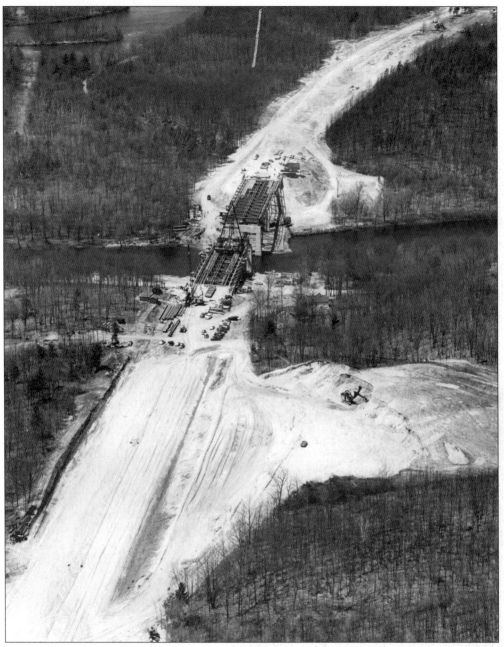

Taken in the spring of 1956, this view shows the construction of the Chicopee River crossing in the small town of Wilbraham. In August 1955, hurricane Diane battered the state and washed away much of the work in progress on this bridge when the river crested.

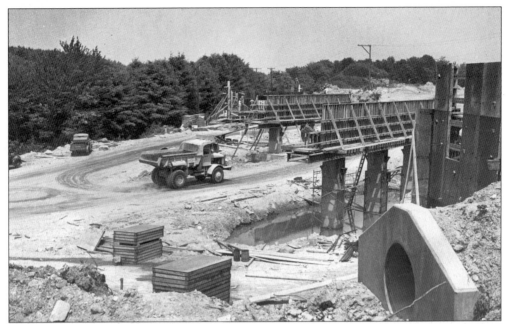

The construction of the Oak Hill Road overpass in Ashland is shown during the early stages of turnpike work. Because bridge building took far longer than road construction, work on many bridges carrying local roads over the turnpike (and vice versa) started even before the turnpike's right-of-way had been fully cleared.

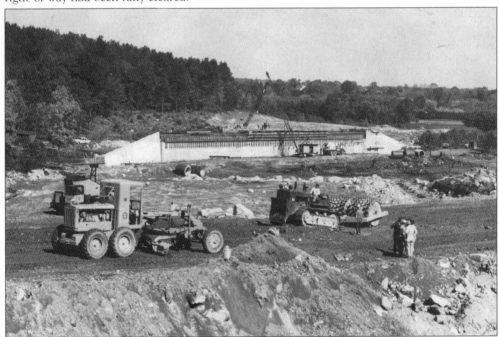

Work is in progress on the underpass for the New York, New Haven, and Hartford Railroad's Agricultural branch in Framingham just east of the Route 9 interchange. The tracks run between the pair of long concrete walls in the center of the image. The land in the background, to the west, has yet to be cleared for the right-of-way.

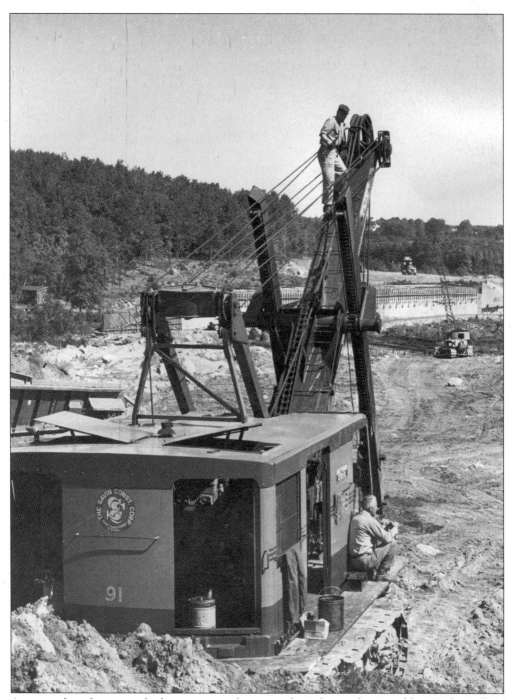

A power shovel operator looks on as a mechanic tends to the machine's cables. With much of the work being performed in remote areas, equipment had to be maintained and repaired in the field by their crews. One of the most common problems on the job was broken cables on power shovels, such as the one pictured here in Framingham.

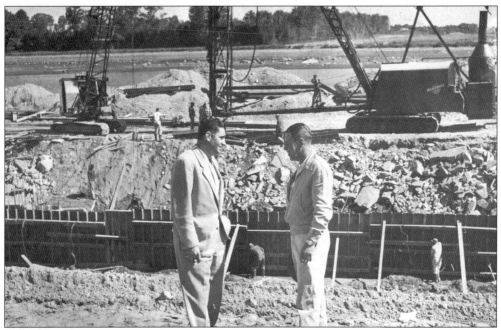

Pictured on the left is Martin DeMatteo, vice president of DeMatteo Construction. On the right is Wendell Carter, president of Carter Piledriving. The DeMatteo company built two sections of the initial turnpike through Framingham and Hopkinton. It subcontracted the work of driving support piles for the 22 bridges in their sections to Carter.

This view looks east from the site of the future Route 30 overpass in Framingham. In the distance, the curving swath of cleared land for the turnpike right-of-way is visible. Just visible at center is the New York, New Haven, and Hartford Railroad's Framingham and Lowell branch, the overpass for which has yet to be constructed.

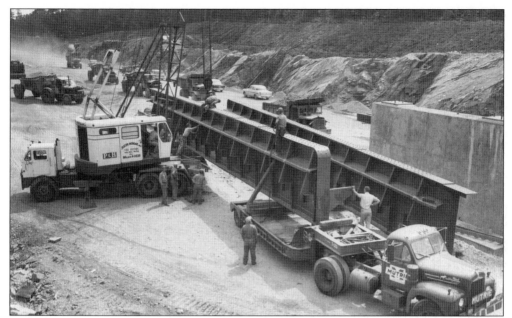

Workers prepare to lift one of the massive steel girders that will carry the tracks of the New York, New Haven, and Hartford Railroad's Framingham and Lowell branch over the turnpike. This crossing is just east of the Route 30 overpass in Framingham. Large bridge beams such as these were often shipped by train to the depot nearest their final destination and were then trucked the rest of the way.

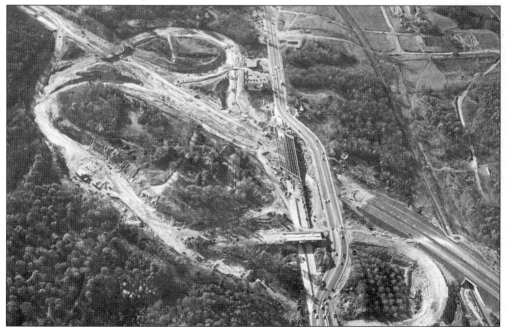

The Route 9 interchange in Framingham is pictured under construction in the fall of 1956. Route 9 has been temporarily detoured around the construction of two overpasses, and the paths of the interchange ramps have been cleared from the surrounding forest. To the left are the beginnings of a toll plaza.

The future site of the toll plaza for the Route 9 interchange is shown carved out of the rocky hill just north of the turnpike near the western border of Framingham. The need to provide toll-collection facilities at interchanges dramatically increased the complexity and cost of their design and construction, but there was no alternative to the toll road in the years before federal financing became available.

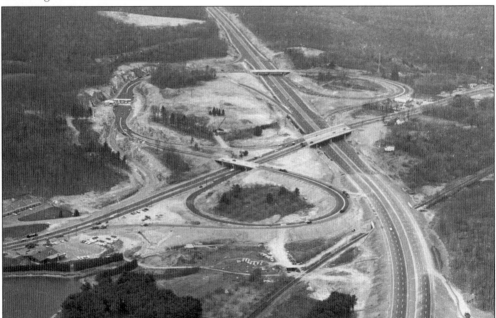

The old meets the new in Framingham at the completed interchange of Route 9 in the summer of 1957. Route 9 had been completed in the 1930s to serve intercity traffic between Boston and Worcester but proved unequal to the task of coping with the postwar boom in intercity truck transportation and passenger car trips. Of particular note in this view is the lack of development along the Route 9 corridor.

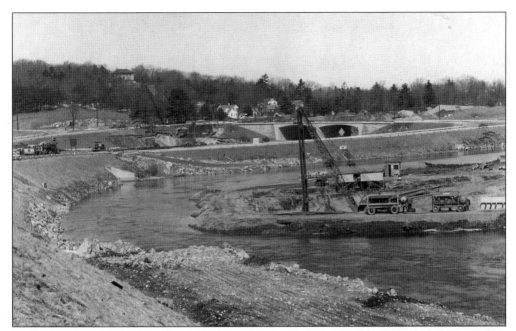

In this April 1956 photograph, a pile driver begins work on the foundation of the turnpike's interchange with the recently completed Route 128 at the Charles River. In the background is one of the handsome old stone bridges that carried local streets over Route 128 when it was still a four-lane road. (Courtesy Perini Corporation.)

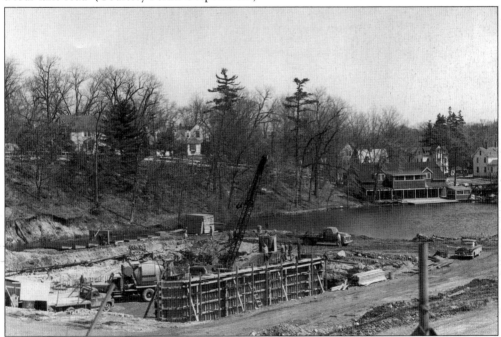

Pictured is the foundation block of one of the turnpike ramps at the Route 128 interchange. In the background is Pigeon Hill in Newton, through which the turnpike extension would tear six years later. To the right is the old terminal boathouse, so named because of its proximity to the Boston & Albany's Riverside terminal. (Courtesy Perini Corporation.)

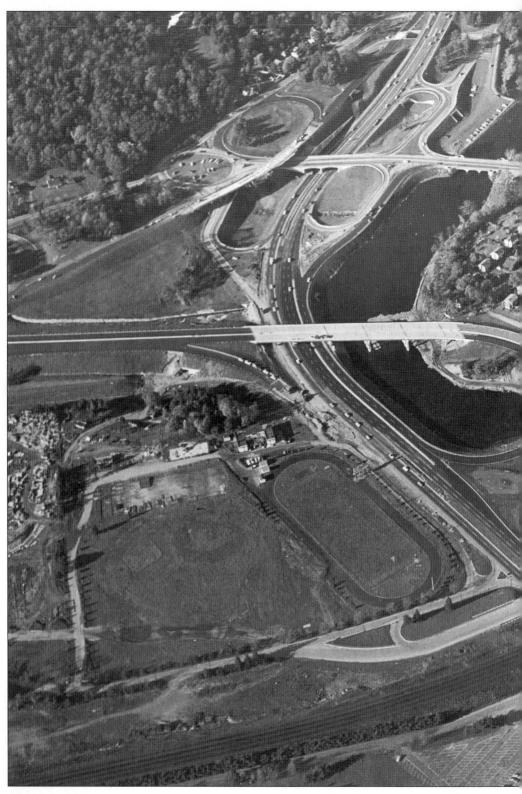

44

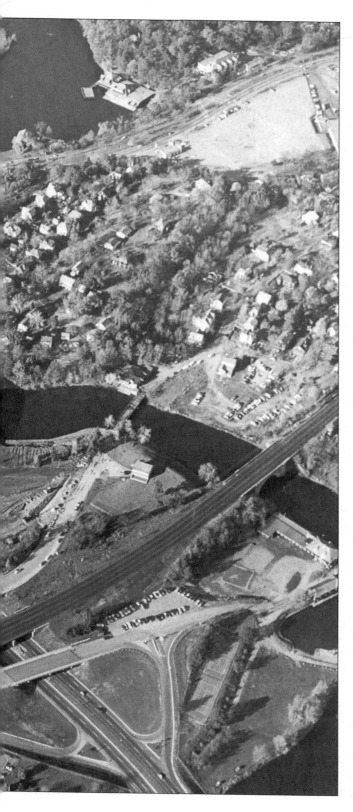

The completed Route 128 interchange is shown in the summer of 1957. The opening of the turnpike would severely tax the capacity of the existing four-lane Route 128 in this area, and a widening project began five years later. At the top center is Route 30, one of the main trunk roads leading into Boston from the initial turnpike's terminus. Lack of convenient access to downtown Boston proved an immediate shortcoming of the new road. Near the curving turnpike ramp over the Charles River is the Pigeon Hill neighborhood of Newton. (Courtesy Perini Corporation.)

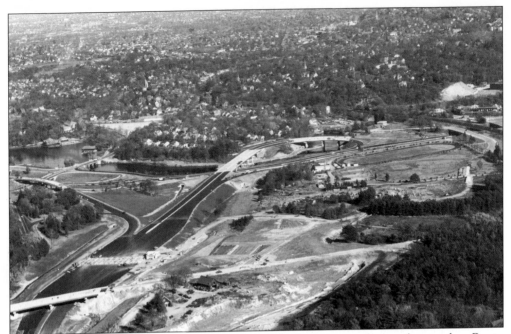

Taken in the early spring of 1957, this photograph looks east over the nearly complete Route 128 interchange toward the city of Newton. Although the initial turnpike ended in a broad, curving ramp (center), the road's alignment pointed straight to Boston, leaving little doubt as to its eventual destination. (Courtesy Perini Corporation.)

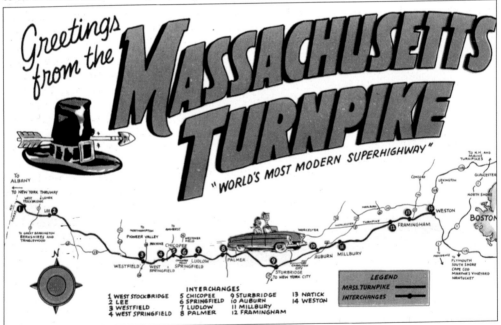

This 1957 postcard marks the opening of the turnpike from the New York border to Route 128, 12 miles from the heart of downtown Boston. The road was the largest public works project in the state's history, but it took only about two years to complete and won widespread praise for Turnpike Authority chairman William Callahan.

46

Three

THE BOSTON EXTENSION

A bright new highway leading into a bright new city . . .
—From the opening ceremony in Allston, September 9, 1964

Soon after the initial turnpike opened in May 1957, it became painfully clear that the 123-mile road was of limited value unless it served downtown Boston directly. From its terminus at Route 128, miles of local streets offered the only access to downtown. William Callahan had stopped the initial turnpike at Route 128 because the cost of building the 12 additional miles of highway into downtown would have made the project less attractive to investors. From the start of the project, however, he made no secret of his eventual intentions to continue the road eastward.

Plans for a highway leading into the city from the western suburbs had originally been included in the state's 1948 Highway Master Plan. However, as costs of other state highway projects already under construction steadily rose (and with Callahan's Turnpike Authority able to finance and construct the road independently), the legislature balked at including the 1948 plan's Western Expressway in new state bond issues. Instead, in the spring of 1955, legislators turned to the Turnpike Authority to undertake the project.

Then, in June 1956, came a dramatic change. Pres. Dwight D. Eisenhower signed into law the Interstate Highway Act, which offered state highway departments 90-percent federal funding for their major highway projects. It suddenly appeared that the Western Expressway could be built as a freeway by the Massachusetts Department of Public Works for a only a dime on the dollar. Overnight, the federal government had rendered the appeal of Callahan's toll road obsolete.

Adding to Callahan's worries, just days after Eisenhower's ink dried, the Prudential Insurance Company announced its intention to purchase the 28-acre Back Bay yards of the New York Central Railroad's Boston & Albany line and develop in its place a massive office and residential complex. The Boston & Albany main line stretched from Riverside Station in Newton near the terminus of the initial turnpike through the Back Bay yards and on to South Station. It therefore appeared to Callahan to offer a tailor-made right-of-way for the turnpike's extension into downtown Boston. Now, however, it appeared that path would be blocked by the planned Prudential development. Callahan announced that he would use the Boston & Albany tracks anyway by taking part of the Prudential holdings by eminent domain. This brought an immediate call for negotiations from the Prudential camp under vice president Fred

Smith, and in time the two men not only reached a compromise but became close allies. That alliance, forged in the spring of 1957, would prove Callahan's savior four years later.

John A. Volpe, Callahan's successor as public works chairman, was a firm advocate of the public works department's Western Expressway proposal from the 1948 Highway Master Plan. Having received assurances from Washington that the Western Expressway could receive 90-percent federal funding, he led a spirited political crusade against Callahan's toll road. In 1960, replacing Callahan's friend and fellow Democrat Foster Furcolo, he was elected governor. In his inaugural speech, he called on the legislature to endorse the public works department's proposed freeway.

The routes proposed by Volpe and Callahan were not identical, however. The proposed Western Expressway route was to reach its eastern terminus in Allston's Beacon Park rail yards. There, at a massive interchange, it was to meet with an eight-lane circumferential highway called the Inner Belt, also outlined in the 1948 Highway Master Plan and eligible for 90-percent federal funding. By contrast, Callahan's toll road would continue past Allston and pierce the heart of downtown, terminating at the Central Artery near South Station. The most important difference between the two roads, however, came at a point just over one mile beyond the Beacon yards, where Callahan's highway sprouted an eastbound exit ramp underneath the Prudential Center.

In November 1960 (barely a week after Volpe was elected to the governorship), Prudential issued a press release describing Callahan's toll road as an "essential" part of the project. Volpe apparently either did not notice the release or failed to heed the message it so thinly veiled. A week after his inauguration in January 1961, at the request of Newton mayor Donald Gibbs, Volpe filed a petition with the Interstate Commerce Commission to block the sale of the Boston & Albany right-of-way to the Turnpike Authority and thus derail Callahan's plans. Prudential officials quickly called a meeting with the new governor. After several days of meetings between Volpe and Prudential, Callahan was invited to join. The next morning, the papers carried the news: Volpe would withdraw his petition to the Interstate Commerce Commission and was "hinting compromise." A week later, it became official. "It's a Toll Road," blared the *Boston Globe*. Volpe characterized his decision as one "between the Prudential and the freeway" and admitted that he had been unaware of "a complicated and extensive series of contractual commitments between the Turnpike Authority, the Prudential Insurance Company . . . and the city of Boston." Callahan had won his fight to build his turnpike into downtown.

Winning the political fight with Volpe did not bring an immediate start of construction on Callahan's toll road, however. The Turnpike Authority relied on the sale of its revenue bonds to provide financing for the $180 million project, but the appeal of toll road bonds had evaporated overnight when Eisenhower signed the Interstate Highway Act into law five years earlier. Callahan's first attempt to market the extension bonds fell flat in April 1961. A second offering in June fared little better. Not until the winter of 1962 (seven years after securing legislative approval for his plans) was Callahan finally able to market his bonds successfully and begin construction.

On a cold February morning in 1965, a brief ceremony marked the opening of the turnpike extension from Route 128 to the Central Artery. Callahan would not live to see the completion of the road he devoted the last decade of his life to building. His passing in April 1964 marked, in the words of the *Boston Globe*, "the end of an era." The controversial road builder had changed the shape of Boston forever and, along with it, the attitudes of its residents and power elite. In the end, Callahan had built more than just highways in Boston; his road-building program had built in the hearts and minds of the city's people potent antibodies against the highway programs still threatening the city's neighborhoods. As a result, by the close of the 1960s, plans for two major expressways—the Inner Belt and the Southwest Expressway—had been abandoned.

The construction of the turnpike extension marked the last gasp of a political and planning community enamored of big plans and indifferent to their often devastating consequences. It would take an even bigger plan (the current Central Artery/Third Harbor Tunnel project) to reverse some of those impacts and bring Callahan's legacy full circle.

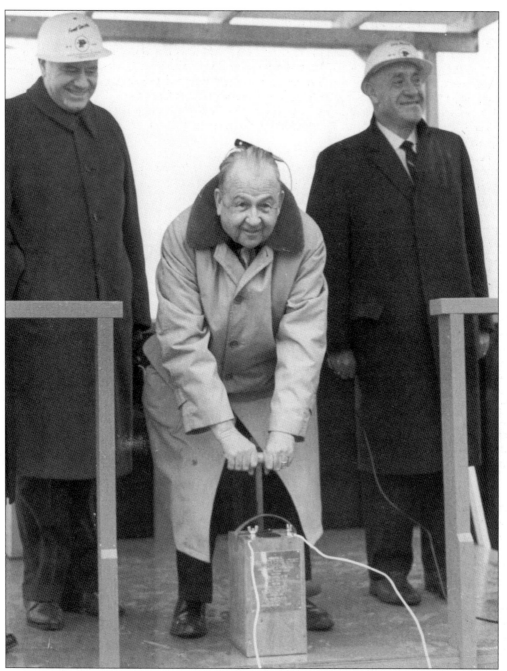

The groundbreaking ceremony for the turnpike extension is shown on March 5, 1962. Replacing the traditional spade of earth, Callahan opted instead for a ceremonial blast of dynamite. Just before pushing the plunger and blasting away a ledge in the town of Weston, he quipped, "I only wish some of my critics and enemies were sitting on top of that ledge." On the left is Fred Smith, vice president of the Prudential Insurance Company, which handsomely benefited from the direct highway access offered by the turnpike to its Back Bay development. On the right is Lou Perini, president of the Perini Corporation and Callahan's favored contractor.

This 1962 map shows the route of the turnpike extension from Route 128 in Weston into downtown, ending at an interchange with the Central Artery. Gov. John Volpe's proposal for a western freeway would have ended at the Inner Belt highway in Beacon Park yards. Shown

in dotted lines are the expressways proposed as part of the 1948 Highway Master Plan, including the Inner Belt. Of all the proposed highway projects denoted on this map, only the Route 93 connector through Somerville and Medford was ever built.

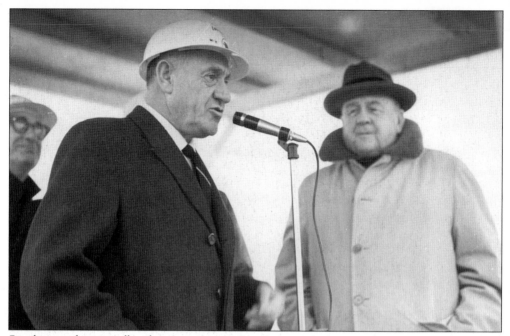

Speaking at the groundbreaking ceremony is Lou Perini, owner of the former Boston Braves and close friend of William Callahan (right). The Perini Corporation built large sections of the initial turnpike, the Lt. William Callahan Jr. Tunnel (completed in 1961), the turnpike extension, and the Prudential Center. Because the Turnpike Authority was not bound by state bidding laws, Callahan awarded the Boston extension job to a Perini-headed joint venture strictly on a negotiated-price basis. (Courtesy Perini Corporation.)

As young Margaret and John Kenner look on, engineers perform soil tests on Pigeon Hill Road near the banks of the Charles River in preparation for the start of construction. (Courtesy Perini Corporation.)

In the spring of 1962, a railcar-mounted crane takes up tracks in Newton. The first order of business once the Turnpike Authority had received the $180 million cash proceeds of its bond sale in January 1962 was to clear the right-of-way for the new road. The Boston & Albany finalized the sale of its tracks to the Turnpike Authority in February. (Courtesy Perini Corporation.)

This June 1963 view shows the newly graded roadbed of the extension as it branches off the initial turnpike just west of Route 128. At the center of the image are the foundations of the Weston toll plaza. In the distance is the steel viaduct that carries the extension over Route 128 and the Charles River and into Newton.

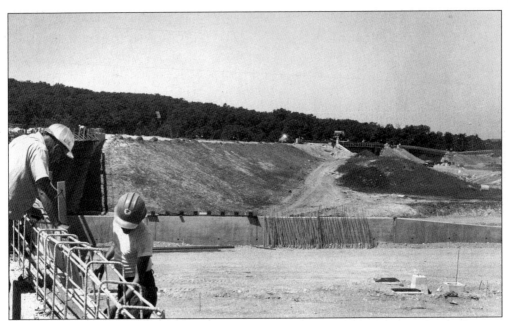

On a hot summer day, workers prepare steel reinforcing bars atop one of the bridges making up the new Route 128 interchange. The new entrance and exit ramps had to be carefully threaded over and around the initial turnpike's interchange, completed only six years before.

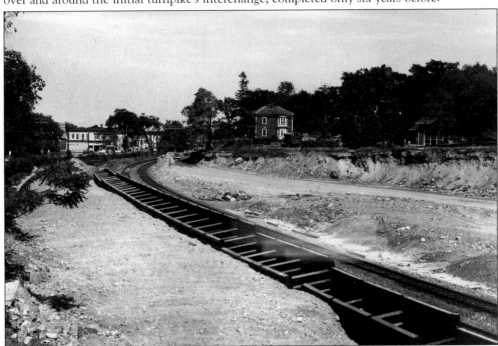

This house on Central Street in Auburndale has only a few weeks to live in June 1963. Families whose properties stood in the way of the new highway received only 30 days' notice to vacate before the Turnpike Authority took title. The extension's construction displaced some 550 families in Newton, many of whom complained bitterly about the treatment they received from William Callahan's field personnel. One irate homeowner cited their "terror, nastiness . . . and insults."

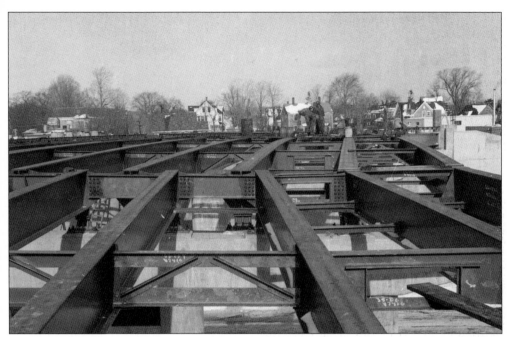

This view shows the steel skeleton of the West Newton exit ramp as it loops over the remaining pair of Boston & Albany tracks. The ramp served primarily those residents of Newton (including William Callahan himself) who commuted daily to work in downtown Boston—the very same commuters increasingly stranded by reductions in commuter rail service that began in the late 1950s. (Courtesy Perini Corporation.)

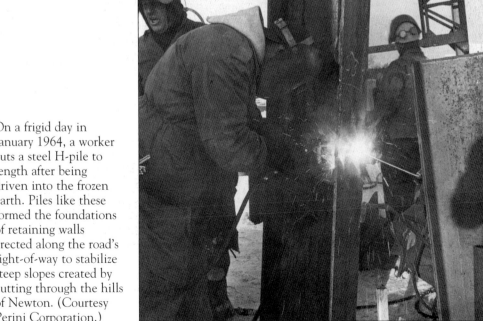

On a frigid day in January 1964, a worker cuts a steel H-pile to length after being driven into the frozen earth. Piles like these formed the foundations of retaining walls erected along the road's right-of-way to stabilize steep slopes created by cutting through the hills of Newton. (Courtesy Perini Corporation.)

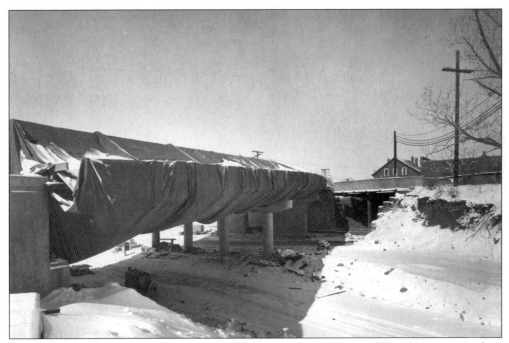

The Auburn Street bridge in Newton's Auburndale neighborhood has been wrapped in insulating material to protect the freshly poured concrete from the effects of ice and snow. In order to bring the new road into operation in minimal time, Callahan and Perini negotiated an accelerated work schedule that entailed working through the winter months.

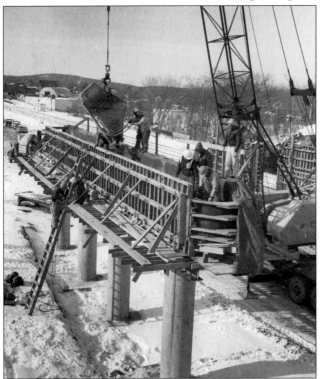

Workers place concrete atop bridge piers in Auburndale. Clearly visible are the insulating blankets that will be wrapped around the fresh pour to prevent the concrete from freezing before curing fully. The advent of the concrete pump truck in the 1970s eliminated the inefficiency of placing concrete one hopper at a time, as shown here. (Courtesy Perini Corporation.)

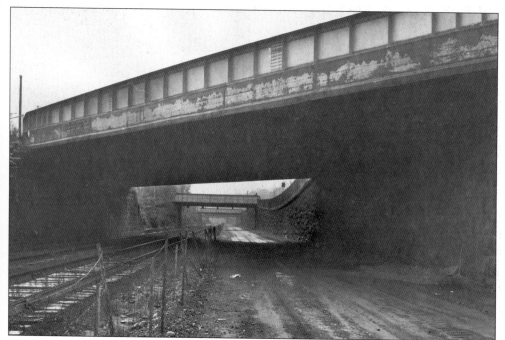

This view shows several of the old bridges that spanned the Boston & Albany tracks as they cut through Newton. The turnpike extension job consisted of $35 million worth of bridge building and barely $30 million in actual roadway construction, as no fewer than 86 new bridges had to be constructed east of Route 128. The West Newton Washington Street bridge is in the foreground.

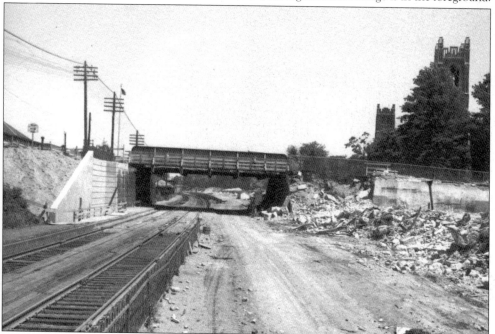

The old Chestnut Street bridge in West Newton is shown here, with the newly constructed abutment of its replacement to the left. To the right is the pile of rubble that was once the West Newton depot, designed in 1882 by H.H. Richardson.

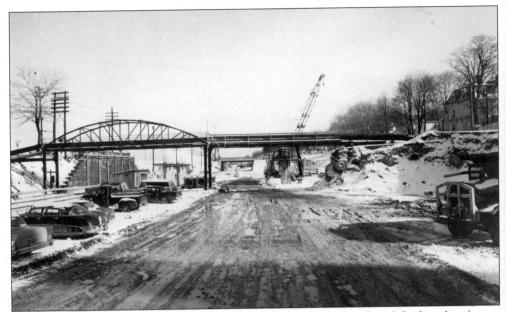

In this 1964 photograph, the Chestnut Street bridge has been demolished and a former pedestrian overpass (serving the Newtonville depot) has been adapted and lengthened to carry utility lines across the turnpike right-of-way. Utility reconstruction all along the extension corridor was a major expense to the Turnpike Authority, accounting for more than 10 percent of the total project cost.

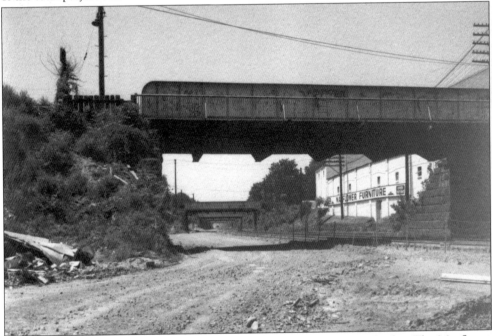

This view looks west in the summer of 1962 under the Chestnut Street bridge. The Mayflower Furniture building (right) still stands today. The Boston & Albany Railroad ran at grade through Newton until the mid-1890s, when traffic conditions necessitated the construction of the depressed right-of-way and overpasses for the former surface streets all along the rail corridor.

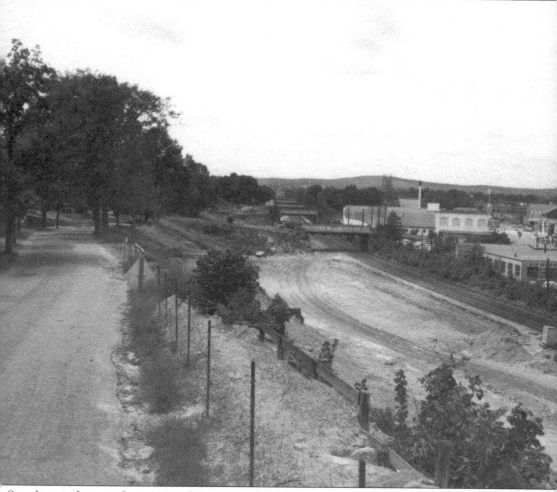

Seen here is the view from Austin Street atop a large hill in Newton after the turnpike corridor had been cleared in the spring of 1963. The widening of the Boston & Albany corridor in Newton required cutting deep into several major hills (including this one) on the southern side of the rail line to avoid impacting Washington Street. When building the initial turnpike through largely undeveloped land, it proved possible to cut far back into hills to obtain a stable natural slope on either side of the roadway. In densely populated Newton, the Turnpike Authority erected high concrete retaining walls to minimize the cost of taking property alongside the highway corridor.

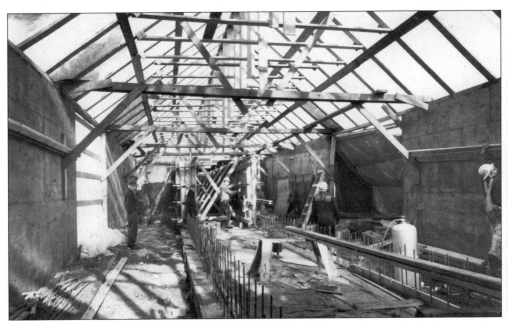

Dating from January 1964, this photograph illustrates the great lengths to which the turnpike's contractors went to maintain their schedule through the winter months. A temporary structure has been erected over the future site of the West Newton toll plazas, heated sufficiently to allow the workers inside to work in relative comfort through the winter.

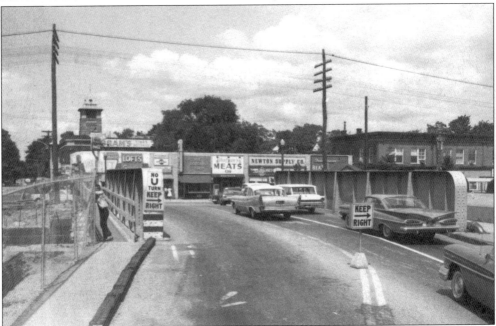

This view over the Walnut Street bridge in Newton shows the neighborhood character of the Washington Street corridor that paralleled the Boston & Albany line prior to the construction of the turnpike. The turnpike brought dramatic change in real estate values in Newton, which almost overnight became a hit with downtown workers seeking a 10-minute commute and a traditional suburban home.

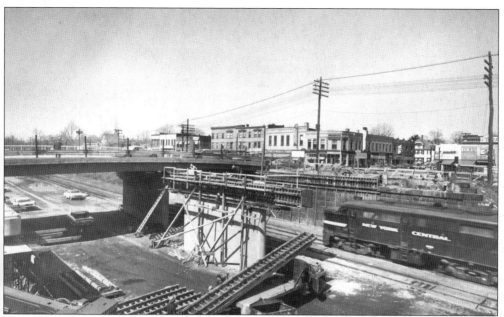

This photograph, taken two years later, shows half of the new Walnut Street bridge in the background, with the remaining half of the new bridge under construction using the old bridge's granite-block abutment on the Washington Street side. In many cases, original bridge abutments along Washington Street were reused, with the addition of a concrete capping beam to bring the new bridges up to grade with the street.

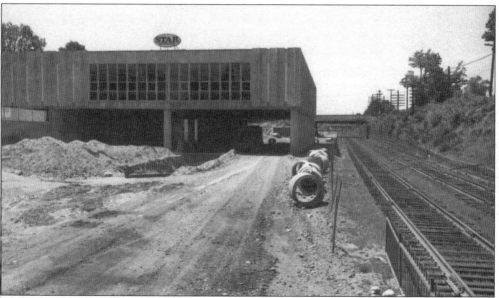

The new Star Market near Walnut Street in Newtonville is shown here. The widening of the Boston & Albany corridor demolished the old Newtonville Star Market, but William Callahan allowed Stephen Mugar, president of the Star chain, to rebuild over the turnpike and on adjacent land even before construction of the road had been completed. The arrangement led one Newton resident to complain that their home had been taken solely to accommodate the new market's parking lot.

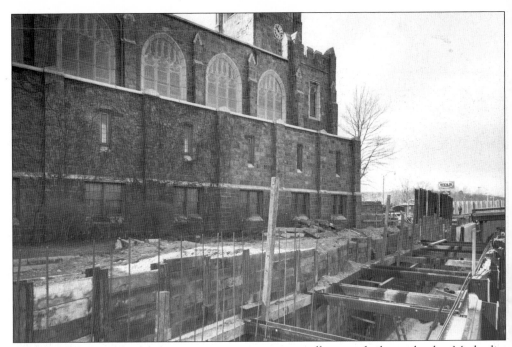

This view shows the elaborate temporary retaining wall erected alongside the Methodist church in Newtonville to protect its foundations while work proceeded on the permanent roadway wall.

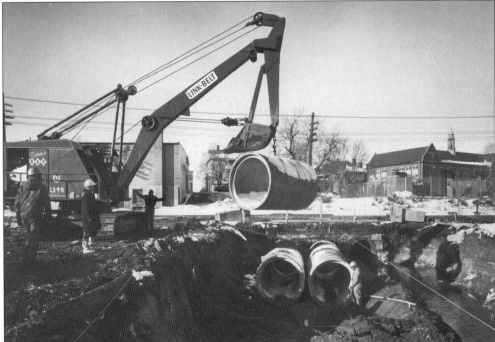

In the winter of 1964, crews are laying a 60-inch concrete pipe to carry the Laundry Brook under the roadway. The old culvert, constructed by the Boston & Albany in the 1890s, is visible just beyond the row of new pipes.

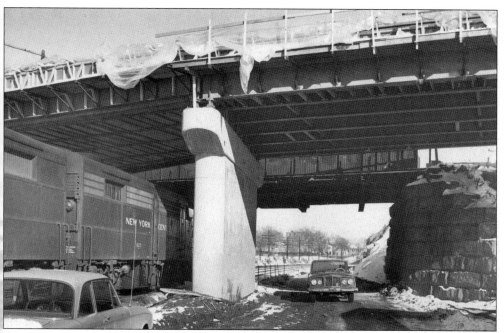

This dramatic image shows both old and new bridges carrying Lewis Terrace over the Boston & Albany tracks and turnpike corridor, respectively. The passing locomotive illustrates the close quarters in which the construction crews often had to operate. Although the extension would ultimately help to put the Boston & Albany out of business, special Boston & Albany trains were frequently hired to bring materials straight to trackside job sites.

Pictured here just prior to demolition is the old Center Street bridge in Newton Corner. Although most of the bridges in Newton crossed perpendicular to the railroad cut, the street alignment at Newton Corner required the Center Street bridge to cross on a long, shallow diagonal. Because Center Street carried a heavy traffic flow, the longer span had to be supported with the truss structure shown here.

A mangled wire fence separates the old from the new in the summer of 1963. To the right, the former railroad corridor has been cleared, providing a convenient access route for construction traffic all along the extension's alignment. This arrangement kept construction vehicles off local streets, even as many of those streets were gobbled up by the threefold widening of the corridor.

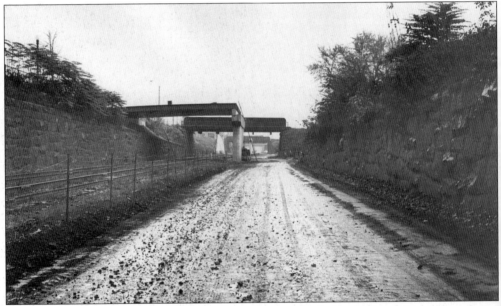

Here is a similar view only four months later, showing the half-completed Richardson Street overpass in front of the structure it is replacing. In order to keep traffic flowing during construction, some new bridges were completed before the demolition of their predecessors. In some instances, old bridges were rebuilt in place by closing half the bridge lanes to traffic, reconstructing the closed lanes and then switching traffic onto the new lanes while the remainder of the work proceeded.

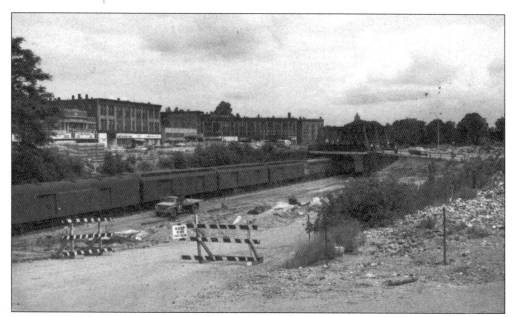

This overview of Newton Corner shows a New York Central freight train passing under the old Center Street bridge. This area would be completely transformed by the construction of the Newton Corner interchange. Newton mayor Donald Gibbs fought the interchange plan bitterly during the road's planning stages, but his appeals to the Turnpike Authority and state legislature fell on deaf ears.

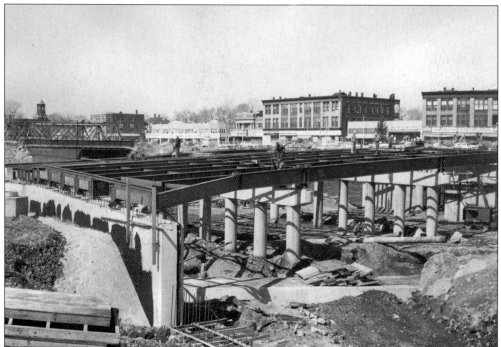

Here, in March 1964, is the Newton Corner interchange under construction. With the old Center Street bridge to the left, workers secure the new Washington Street bridge deck in place. This interchange would soon become one of the most heavily congested on the turnpike.

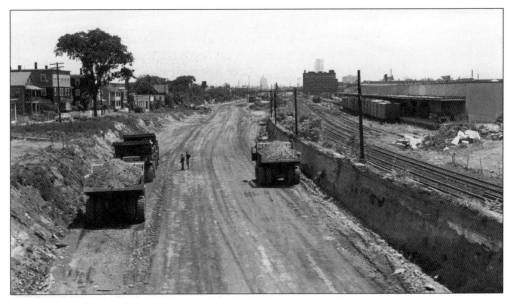

The Boston & Albany rail bed crossed under the turnpike east of Newton Corner and is seen here on the southern side of the road's right-of-way in Brighton. To the left in this image, taken from the Market Street bridge, is what remains of the Lincoln Street neighborhood visible on the top of page 17. The Gentile family successfully brought suit against the Turnpike Authority in June 1964 after receiving an initial damage consideration of $1 for their property in July 1963.

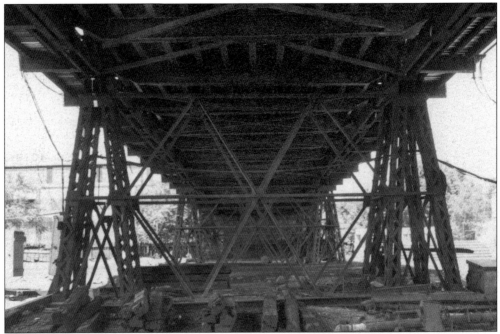

An interesting view from beneath shows the intricate structural system of the old Everett Street bridge, constructed in the early 1890s just west of the Boston & Albany's Beacon Park yards. On either side of the rail corridor along Everett Street sat massive steel-storage warehouses of U.S. Steel and Ryerson Steel.

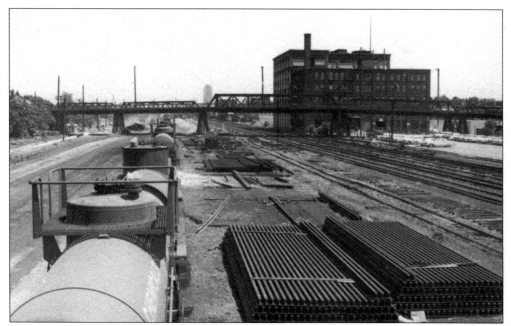

This view looks east over a line of tanker cars toward the old Everett Street bridge in Brighton. Just beyond the bridge are brick warehouses constructed in 1914. To the right are piles of track taken up by turnpike contractors. This part of Brighton was once home to sprawling complexes of slaughterhouses and meat-processing facilities.

This view from the Cambridge Street bridge looks east over the Beacon Park rail yards. Once home to the New York Central's freight train assembly and maintenance facilities, the turnpike took over 130 acres of the yards for its interchange and split the cost with the railroad of replacing the old freight yards with more modern intermodal facilities.

From the Cambridge Street bridge, a Brighton resident surveys the construction near the old yardmaster's office in the Beacon Park rail yards. Completed concrete walls for an interchange ramp approach are visible to the left of the office.

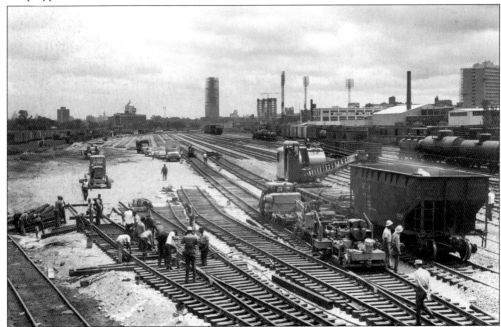

The reconstruction of parts of the Beacon Park yards was financed partly by the Turnpike Authority and partly by the New York Central Railroad. In this photograph, taken in the fall of 1963, crews are laying new tracks at the yard's northern edge. To the right, the light towers of Nickerson Field are visible behind the Pittsburgh Plate Glass warehouse. In the distance, the skeletal structure of the Prudential building is nearly complete.

These viaducts form part of the complex interchange at the Beacon Park yards. The design of this interchange was complicated by existing plans of the state department of public works to construct the Inner Belt (a circumferential highway just outside the central city), which was also slated to pass through the Beacon Park yards. William Callahan had agreed to adapt the turnpike interchange if the Inner Belt were constructed, but it never progressed past the drawing boards. (Courtesy Perini Corporation.)

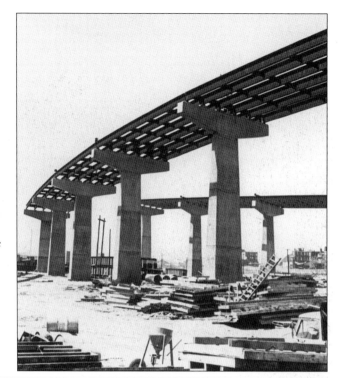

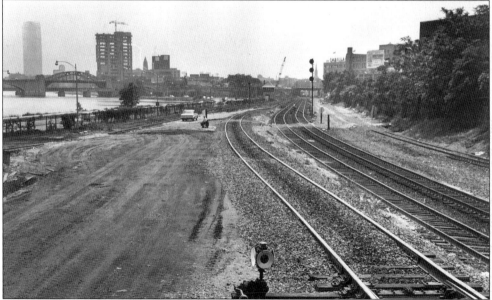

Here, with the Charles River and the Metropolitan District Commission's Storrow Drive to the north (left) and the remaining Boston & Albany tracks to the south, the turnpike had to take to the air in a quarter-mile viaduct. Callahan had originally planned to fill part of the Charles and push Storrow Drive farther out into the river to make way for the turnpike right-of-way, but a protracted legal battle with the Metropolitan District Commission ended in their favor. In September 1964, Callahan's replacement, John Driscoll, had to sell $38 million in additional bonds to fund the viaduct's construction.

The deck of the viaduct behind Boston University is shown ready for concrete to be placed to form the permanent roadway deck. The rows of shear studs welded to the tops of the bridge's beams maintain a tight lateral joint between the concrete slab and the steel beams supporting it as the bridge deck expands and contracts in heat and cold. (Courtesy Perini Corporation.)

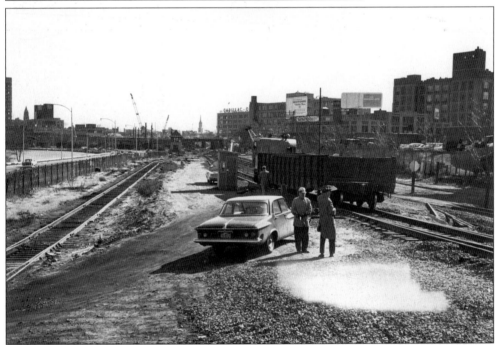

Behind Boston University's Nickerson Field, Turnpike Authority engineers survey the corridor soon to be overshadowed by the turnpike's elevated section. William Callahan's popularity and influence among the state's legislative branch did not extend to the judiciary branch, which eventually settled the Metropolitan District Commission dispute and cost the Turnpike Authority $38 million.

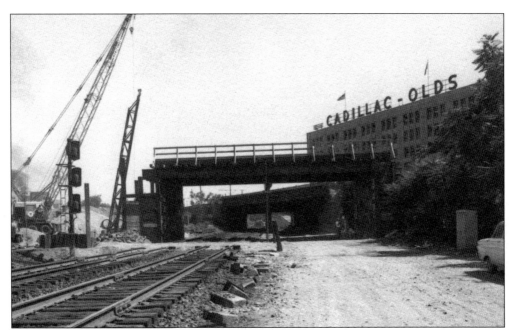

This view looks east toward the old Commonwealth Avenue bridge and the Cadillac-Oldsmobile dealership (built in 1928 and today occupied by Boston University). The unfinished bridge in the foreground is a temporary structure that will carry westbound traffic while the Commonwealth Avenue bridge is reconstructed one half at a time.

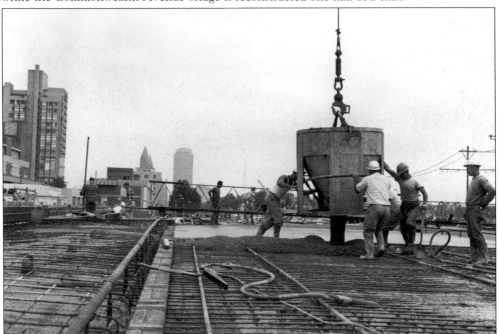

Workers are placing the concrete deck of the new Commonwealth Avenue bridge with a newly completed Boston University tower (left). The entire extension job used about 210,000 cubic yards of concrete, much of it placed one hopperful at a time. At the peak of construction activity, more than 1,100 workers were on the job at one time. (Courtesy Perini Corporation.)

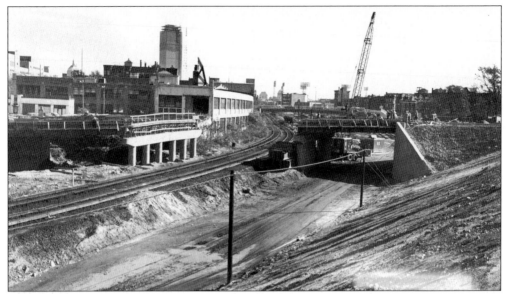

This view looks east at the new Carlton Street bridge from the Cadillac-Oldsmobile building in the fall on 1963. The city of Boston sought to eliminate a longtime traffic bottleneck at the intersection of Commonwealth Avenue and the Boston University bridge by negotiating with William Callahan to build a new bridge at Carlton Street into a reconfigured roadway pattern. In return, they agreed to abandon the much larger Broadway bridge near South Station to save Callahan the expense of its reconstruction.

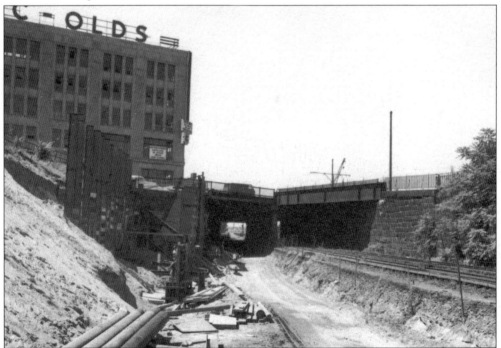

This view looks west from below the intersection of Commonwealth Avenue and Essex Street in Brookline. At this point, the turnpike skirted the elite Cottage Farm section of Brookline, after which the Boston University bridge was originally named when it opened in 1928.

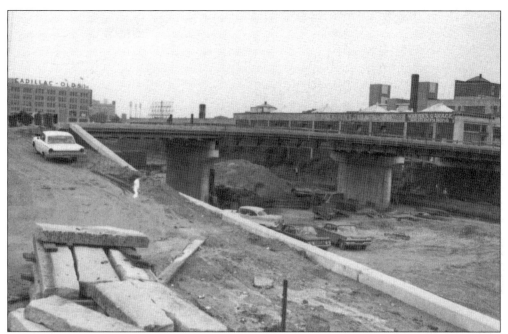

Here is the completed St. Mary's Street bridge in 1964, with the relocated Mountfort Street to the left. Merry's Garage, built in 1919, stands to the right.

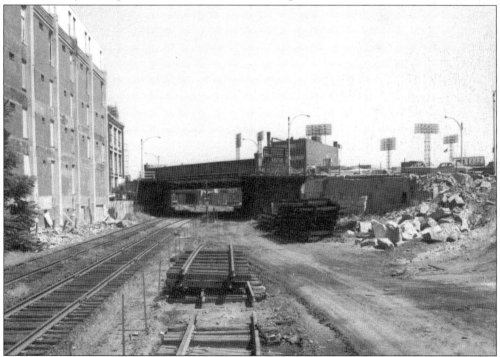

With the light towers of Fenway Park visible in the distance, this view shows the old Beacon Street bridge leading into Kenmore Square from Brookline. After the abutment of the old bridge was demolished, the two tracks on the left were relocated to the other side of the right-of-way. To the left is the back of the old Boston University Science Center, built in 1916.

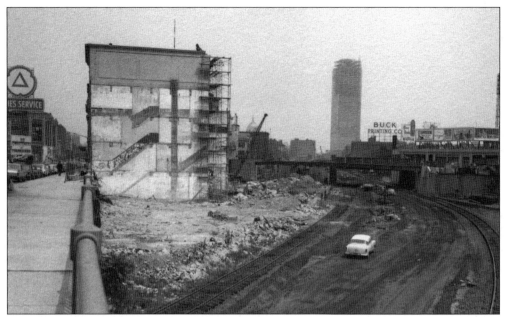

This view looks northeast into Kenmore Square from the Beacon Street bridge. In the distance, part of the rebuilt Brookline Avenue bridge has been completed and one of the old Boston & Albany tracks has been relocated to its final position on the south side of the turnpike right-of-way. The cleared lot at the center was once the site of the Boston Edison offices, at 689 Beacon Street.

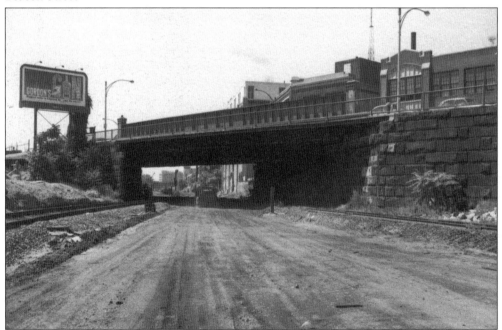

Looking west under the old Beacon Street bridge, this photograph shows the rubble of the old Kenmore movie theater to the far left. The Kenmore was one of two theaters demolished as part of the turnpike construction. The other was the Capri Theater, on Huntington Avenue across from the Boston Public Library.

74

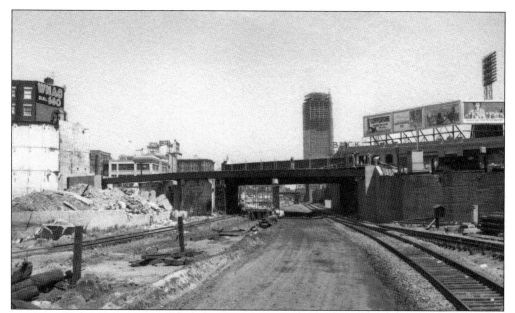

In this view, looking east from beneath the Beacon Street bridge toward Brookline Avenue, Fenway Park is to the right. The structure of a small span carrying utility lines over the turnpike right-of-way is visible in front of the old Brookline Avenue overpass.

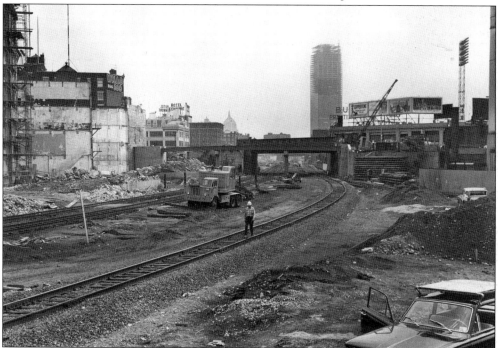

The aftermath of the demolition work along Beacon Street (left) is shown in the summer of 1963. Also visible is one of the relocated railroad tracks running along the southern edge of the turnpike's alignment. This strip of land had been excavated five years earlier as part of the construction of the Metropolitan Transit Authority's Riverside line, which passed beneath the existing Boston & Albany tracks through a tunnel before surfacing just west of this area.

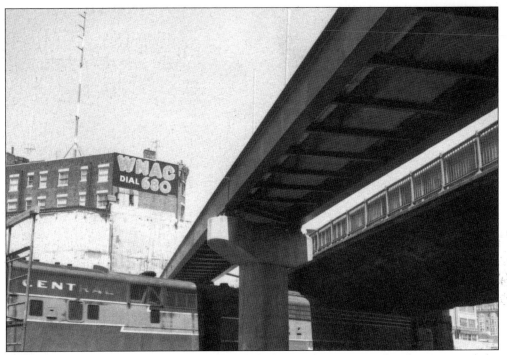

A New York Central locomotive passes beneath the newly constructed utility span and the Brookline Avenue bridge in the spring of 1963.

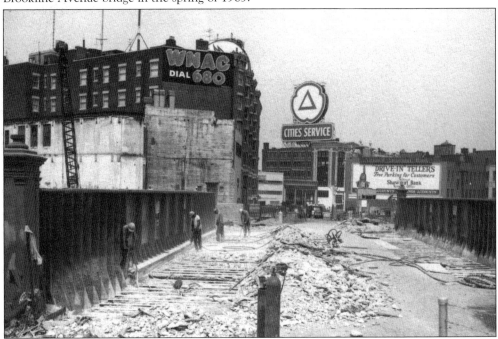

This view from the summer of 1963 shows the demolition of the old Brookline Avenue bridge just outside of Kenmore Square. In the distance is the old Cities Service sign, which became the now legendary Citgo neon sign in 1965. The building at left, built in 1899, housed the Hotel Buckminster.

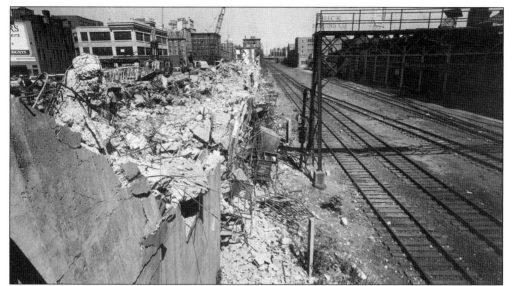

In this 1963 photograph (looking east from Brookline Avenue), the row of industrial buildings that once lined the western end of Newbury Street has been demolished. Compare this image to the similar view on the bottom of page 19. (Courtesy Boston Public Library, Prints Department.)

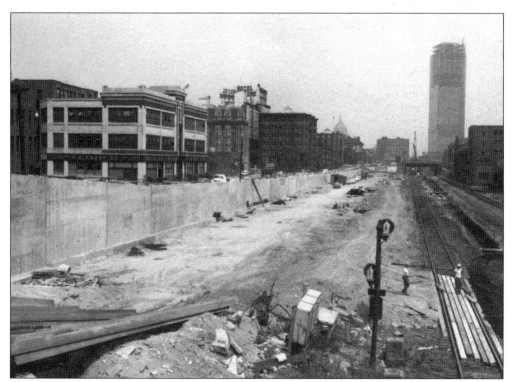

The high retaining wall erected tight to the curb of the Newbury Street extension behind Kenmore Square is seen in this view, looking east from the old Brookline Avenue bridge. The width of the original Boston & Albany rail bed is marked by the signal tower (foreground), which once stood at the edge of the railroad's right-of-way.

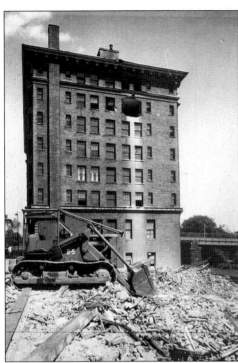

In August 1963, the Hotel Canterbury on Newbury Street behind Kenmore Square is being gutted. Completed in 1905, the Canterbury was one of a string of hotels constructed at that time near Kenmore Square. To the right is the old Charlesgate bridge. (Courtesy Boston Public Library, Prints Department.)

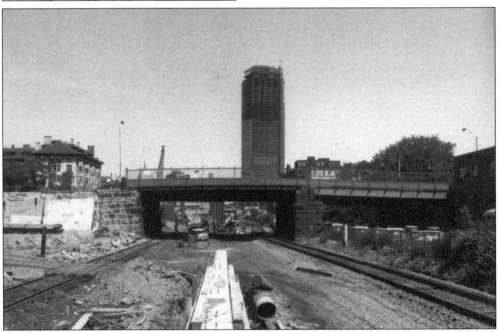

This view looks east toward downtown Boston past the old Charlesgate bridge. The old and heavily congested Charlesgate bridge served as the only direct connection between the Fenway and Kenmore Square along the path of the Muddy River. The Turnpike Authority rebuilt the bridge span in 1964 to accommodate the wider right-of-way underneath, and the Metropolitan District Commission began work on the connection to Storrow Drive shortly after the completion of the turnpike's work.

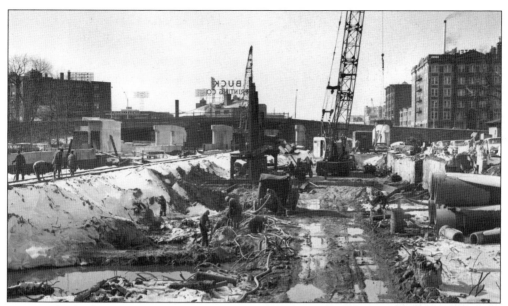

Seen in the background is the old Charlesgate bridge, with the piers of the new Charlesgate East bridge standing ready to receive the steel beams that will support its roadway deck. In the foreground, amid the rubble of basements that once lined the southern side of Newbury Street, excavation work is proceeding for the complex drainage system required to keep floodwaters of the Muddy River from seeping through the future roadbed.

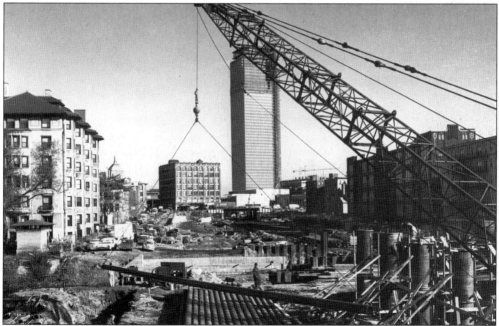

With the Prudential tower in the background, a crane stacks sections of piling for the foundations of the new Charlesgate East bridge. This view gives a good survey of the swath of demolition that accompanied the turnpike extension between Kenmore Square and Massachusetts Avenue (in the distance). The former Hotel Somerset, completed in 1900, is to the far left. (Courtesy Perini Corporation.)

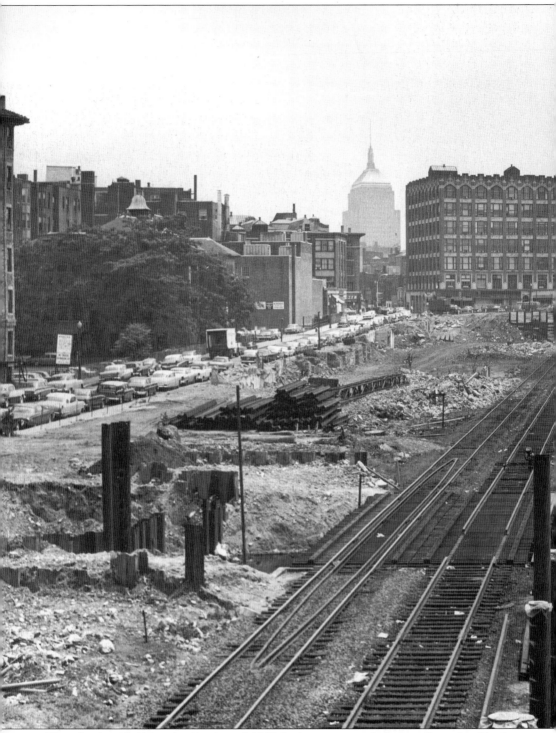

This photograph, from the summer of 1963, looks east toward the city from the Charlesgate bridge, with Ipswich Street on the right. The structure of the Prudential building is complete, and the exterior cladding has progressed just over halfway up the outside of the building. Also

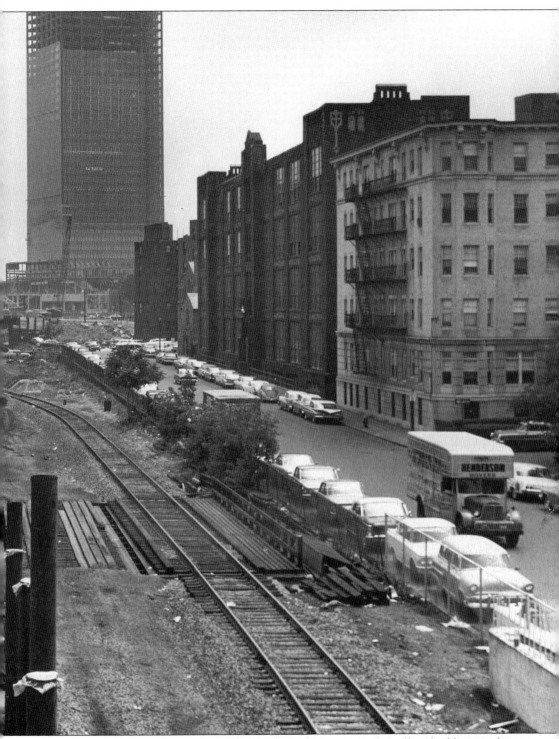

constructed by the Perini Corporation, the Prudential tower was the tallest building in the world outside of New York at the time of its completion. Compare this image to the same view on the bottom of page 20.

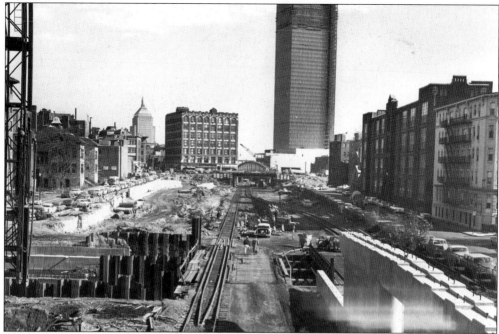

A few months later, the same view shows the completed southern pier of the new Charlesgate East bridge in the foreground and excavation for the Muddy River culvert proceeding under the Boston & Albany tracks just beyond. Twenty-one apartment and warehouse buildings were demolished along Newbury Street to clear the way for the turnpike between Charlesgate and Massachusetts Avenue, leaving a broad swath of cleared land (left).

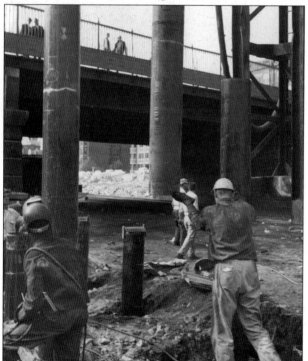

A worker guides a pipe pile into place as passersby look on from the Charlesgate bridge. The pipe piles will be driven into the muddy ground and support the foundations of the new Charlesgate bridges. Used widely in the turnpike's construction, pipe piles were first used a decade earlier during the construction of the first sections of the Central Artery across town. (Courtesy Perini Corporation.)

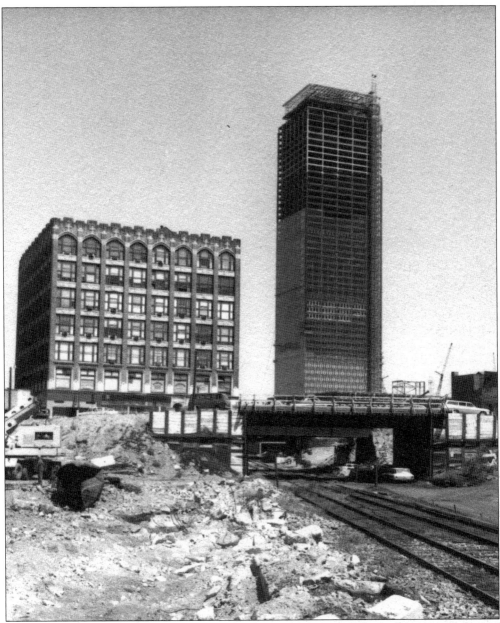

The "New Boston" rises above the old in the spring of 1964. As the new 52-story Prudential Center is topped out, work proceeds on the Massachusetts Avenue entrance ramp at the corner of Newbury Street. A 1962 city of Boston report recommended the elimination of the ramp, citing already problematic traffic conditions at one of the city's busiest intersections. William Callahan ignored the report and built the ramp anyway. To the left is the Transit Building, which earned its name after the corporate headquarters of the Boston Elevated Railway moved in from its old offices at 101 Milk Street. This building received a major renovation in 1991, including a dramatic new cornice designed by architect Frank Gehry.

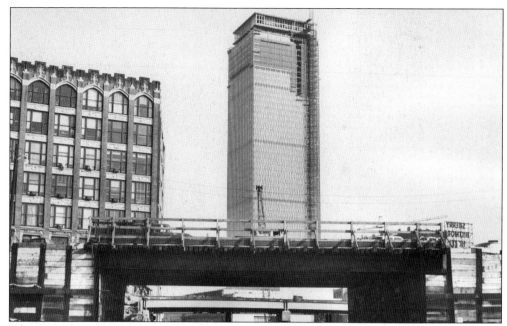

In January 1964, as work proceeds on the new Massachusetts Avenue bridge in the background, a temporary structure with wooden guardrails serves as a detour for traffic. The ornate detail of the original *c.* 1918 facade of the Transit Building is visible to the left, contrasting starkly with the modern aluminum-and-glass skin of the Prudential tower.

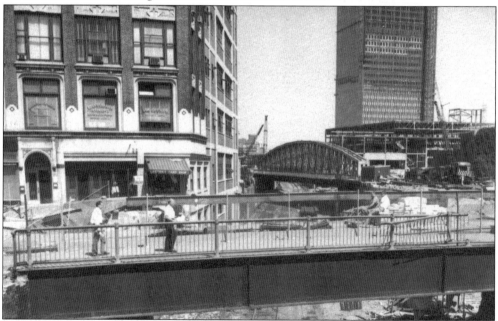

This image, from the spring of 1963, gives an interesting study in architectural priorities. The Transit Building, facing Massachusetts Avenue, is clad in a decorative brick-and-stone facade. The side of the building facing the Boston & Albany corridor and Boylston Street beyond shows the building's bare concrete skeleton and displays no decorative elements whatsoever. The old Massachusetts Avenue bridge has only weeks to live.

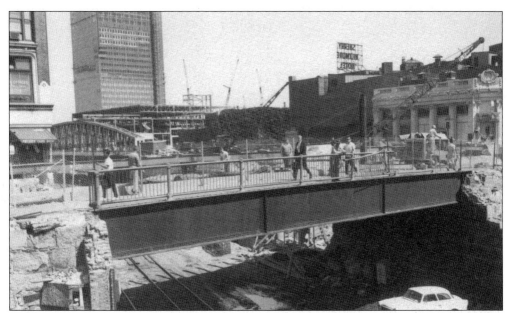

In this image, the old bow truss Boylston Street bridge is visible to the left. The Municipal Auditorium (later Hynes Convention Center), visible under construction past the Boylston Street bridge, had been a part of the Prudential Center development package from the earliest planning stages. It was intended in part to replace the old Mechanics Hall that had been razed to make way for the Prudential tower.

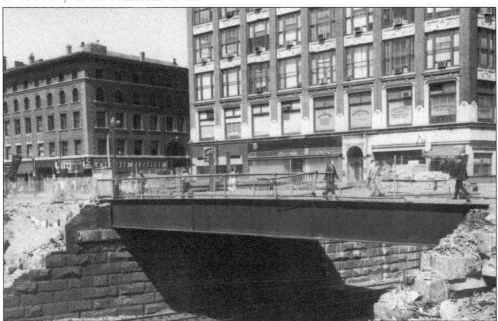

This close-up view of the old Massachusetts Avenue bridge shows the handsome granite block wall that once lined the Boston & Albany rail corridor through the city. Much of the stone was discarded and replaced with concrete when the corridor was widened. Two decades later, when the Southwest Corridor was constructed, granite from the old walls was reused in landscaping the surface park built over the old rail lines.

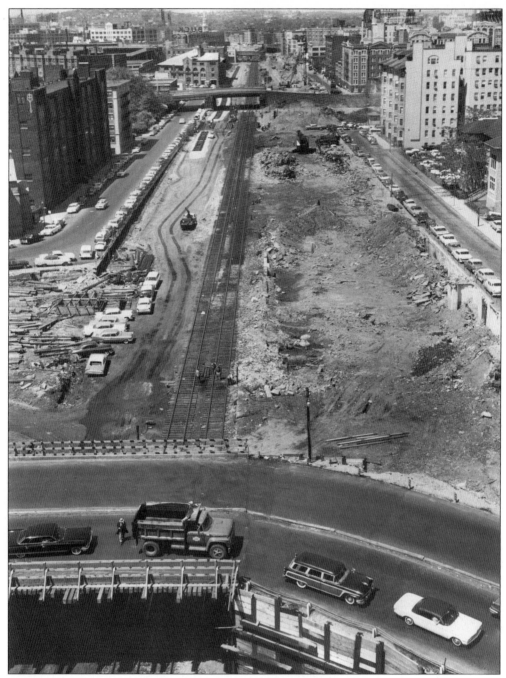

This view, taken from the Transit Building in May 1963, looks west over the temporary Massachusetts Avenue detour and over the swath of cleared land that will soon be graded and paved to form the turnpike's roadway. Newbury Street is on the right, and the remains of basements whose buildings once fronted on the street are just visible between the railroad tracks and the row of parked cars. Ipswich Street forms the southern edge of the future roadway's right-of-way, and the construction of the Charlesgate bridges is visible near the top of the image. (Courtesy Perini Corporation.)

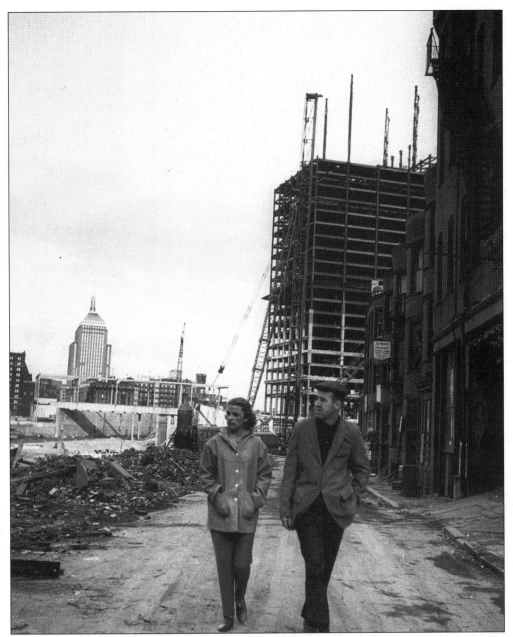

A couple surveys the landscape along Cambria Street as the Prudential tower rises in the background in the winter of 1962. The remaining residences along the south side of the street came down just a few months later to make way for a large parking garage. (Courtesy Boston Public Library, Prints Department.)

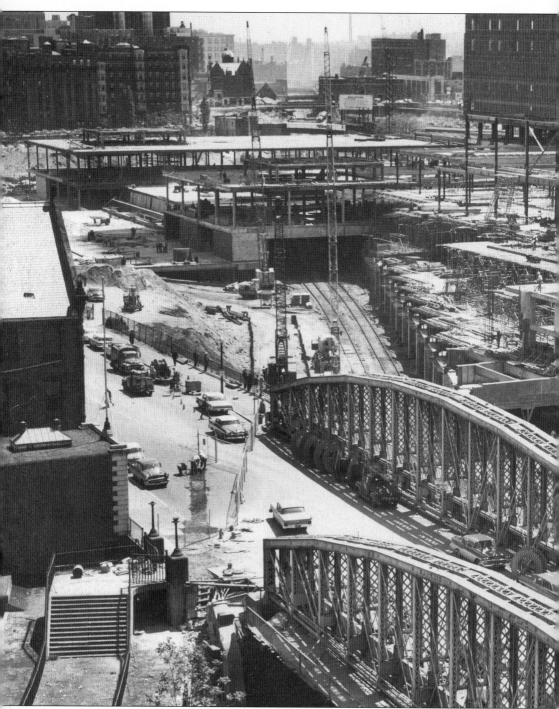

This striking view from the spring of 1963 looks east over the old Boylston Street bridge toward the new $200 million Prudential Center development. In the center is the structural skeleton that will become the Municipal Auditorium (later Hynes Convention Center). In the most important political move of his career, William Callahan was able to link the extension project to Prudential's plans early on. In a city desperate for a commercial project of the scale

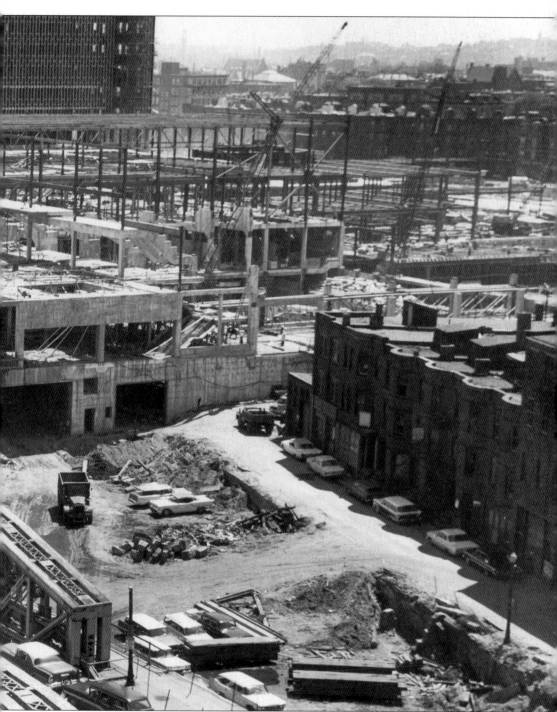

demonstrated in this image, few lawmakers were willing to speak out against the turnpike project once it became clear early in 1961 that without the road, Prudential might pull out of Boston altogether. Only weeks after his inauguration, even Gov. John Volpe beat a hasty retreat from his opposition to the toll road after a meeting with Prudential officials. (Courtesy Perini Corporation.)

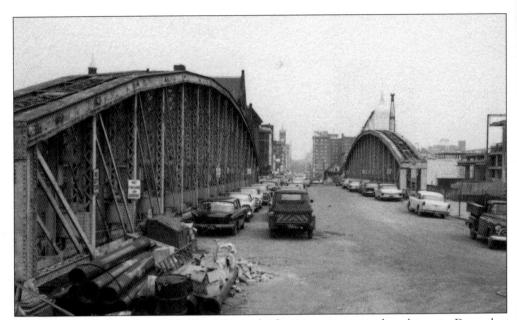

Here is a fine view of the old Boylston Street bridge just prior to its demolition in December 1963. Originally constructed in 1888, the bridge was substantially redesigned in 1907 by MIT professor Charles Spofford to accommodate new 50-ton streetcars. Spofford retained the bridge's original double trusses but sandwiched an additional truss between them on both sides of the roadway in order to strengthen the bridge without dramatically altering its appearance.

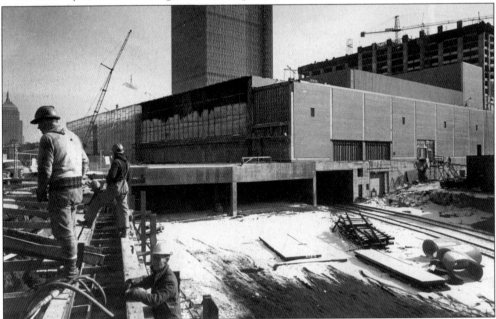

In January 1964, the exterior of the Municipal Auditorium is nearly complete. Clearly visible are the future turnpike and railroad tunnel entrances under the Prudential Center development. Prudential's design engineers had incorporated the eight-lane highway into their foundation drawings as early as 1958, and construction had begun in 1960, only to grind to a halt while William Callahan fought his way through bitter opposition to his toll road.

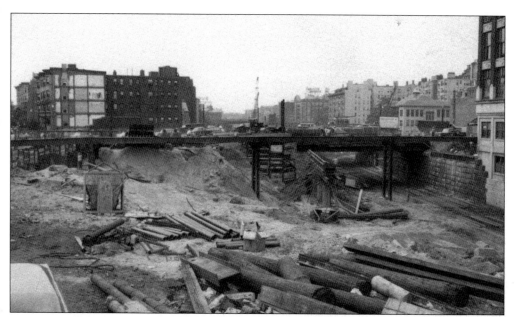

This view looks west from atop the rubble of the old Boylston Street bridge toward the Massachusetts Avenue detour. The turnpike's construction altered this area nearly beyond recognition, eliminating the former Massachusetts Avenue streetcar station, relocating Boylston Street, and creating several large but awkwardly shaped parcels of land that have remained undeveloped for nearly 40 years.

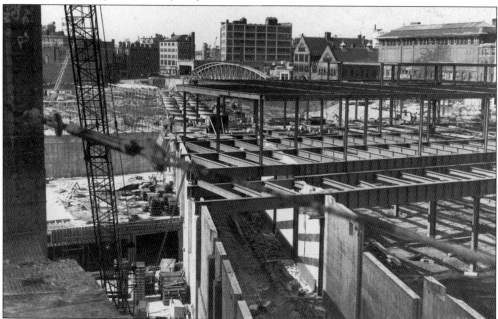

In the foreground of this view (looking west in the spring of 1963) is the narrow corridor that will become the two-track railway tunnel under the Municipal Auditorium and Prudential Center. In order to reduce potentially disruptive noise generated by rail traffic running under the convention space, rubber pads and lag screws replaced the traditional steel track shoes and rail spikes, and seamless rails were substituted for conventional ones. (Courtesy Perini Corporation.)

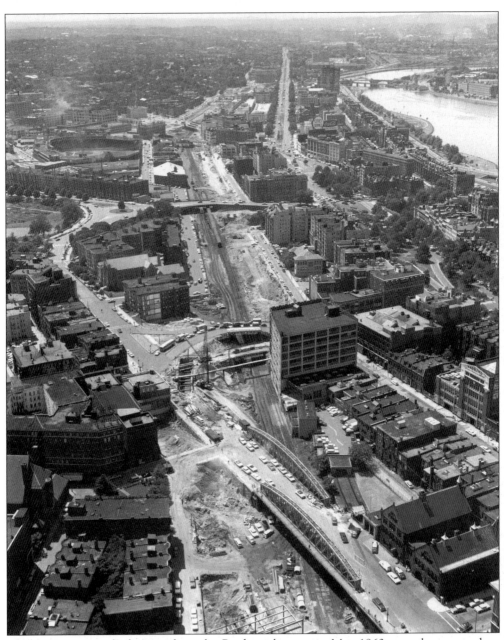

This fantastic view looks west from the Prudential tower in May 1963 over the tremendous swath of land alongside the original Boston & Albany corridor cleared to make way for the new eight-lane expressway. Visible are the two major western routes into the city and the bottlenecks that made them so arduous. To the left are Boylston Street and the Fenway rotary, and to the right is Commonwealth Avenue and Kenmore Square. A 1930 report advocated raising both of these thoroughfares over their respective bottlenecks in elevated structures, but funding never materialized. Note the excavation at the western end of the Boylston Street bridge—for nearly two years, Boylston Street was completely blocked off east of Massachusetts Avenue. Fenway Park is to the upper left. (Courtesy Perini Corporation.)

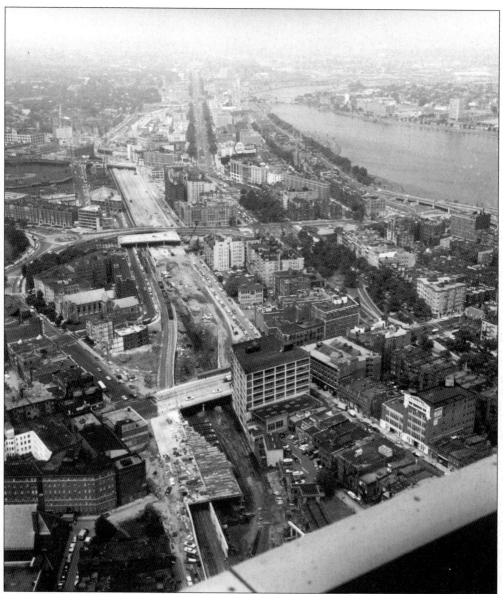

Here is the same view as on the preceding page over a year later. The photograph looks west from the Prudential tower in the fall of 1964. In the foreground, the new Massachusetts Avenue bridge is complete, and the new Boylston Street viaduct is halfway complete. In the center, part of the new Charlesgate overpass is visible. The Turnpike Authority constructed only this portion of the bridge, and the Metropolitan District Commission completed the connections at either end. (Courtesy Perini Corporation.)

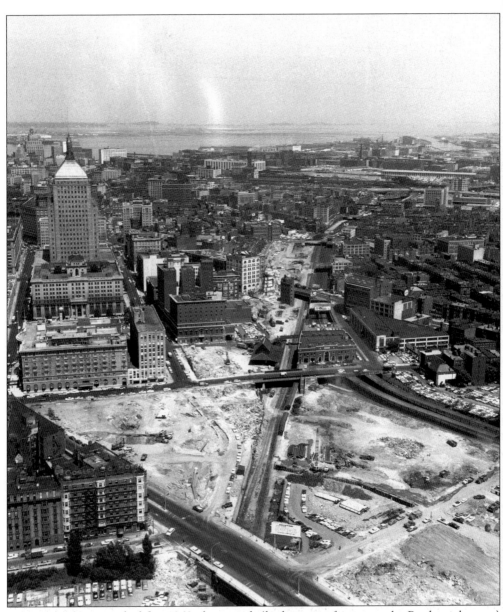

Seen in the foreground of this 1963 photograph (looking east from atop the Prudential tower) are the large tracts of cleared land that will house the Huntington Avenue interchange. Trinity Place station and a handful of other structures have yet to come down. To the right, the New York, New Haven, and Hartford tracks are visible curving into Back Bay station from the southwest. On the parcel of land across from Back Bay station once stood the massive South End Armory (also known as the Irvington Street Armory). To the lower right is the former site of the St. Botolph Street lofts, the demolition of which proved especially contentious. Even Boston Redevelopment Authority director Ed Logue took time away from his destructive slum-clearance programs to plead with William Callahan to redesign the interchange in order to save the buildings. Callahan refused, and demolition proceeded in the fall of 1962. (Courtesy Perini Corporation.)

The old Huntington Avenue bridge is shown just prior to the start of demolition work. Many of the bridges over the Boston & Albany corridor downtown dated from *c.* 1900 and often proved especially difficult to dismantle.

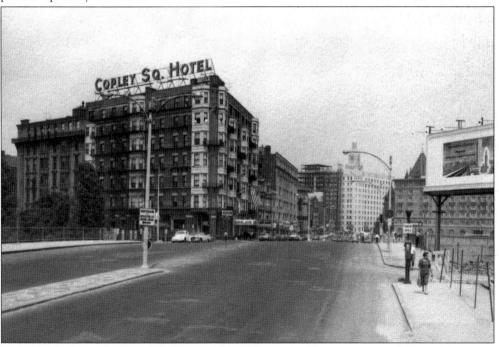

This view looks northeast up Huntington Avenue into Copley Square past a billboard depicting the new Prudential building towering over the city's previous tallest building, the Custom House tower. This view is barely recognizable today, with the Prudential Mall taking up the left side of the street and the Westin Hotel on the right.

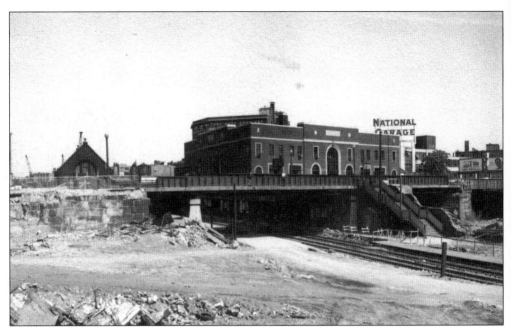

In this view of the Dartmouth Street bridge, stairs leading to the recently demolished Huntington Avenue station still stand on the right. The National Garage behind the Back Bay station was demolished in 1999 to make way for a mixed-use project.

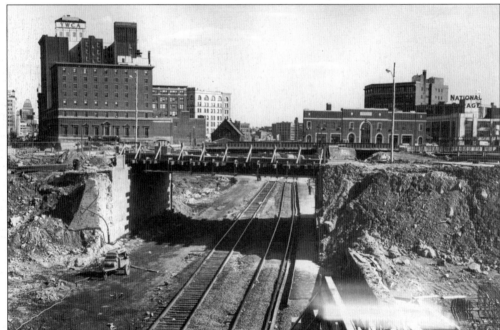

The Huntington Avenue bridge is being dismantled, with the old Back Bay station and the peaked roof of the Trinity Place station visible in the background. In this view, the Boston & Albany tracks remain in their original position. After the old bridge abutments had been cleared away, the tracks were relocated to the southern (right) edge of the right-of-way and served realigned platforms in the existing Back Bay station.

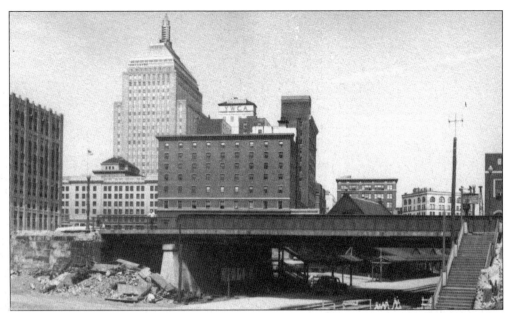

Prominent in this view is the old John Hancock Building, completed in 1947. Although welcomed by a city whose last major office building went up in 1930, the Back Bay site was seen by many as an abandonment of the city's traditional downtown financial district. Many downtown boosters saw the Prudential development in the same light and resented the mayor's willingness to grant Prudential tax incentives to locate outside the city center.

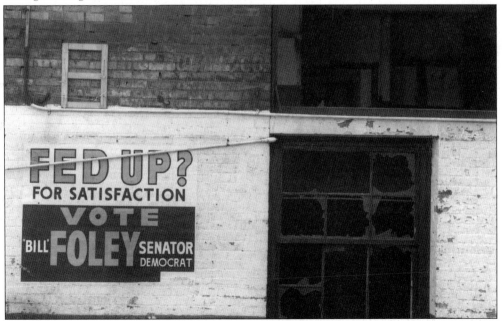

Plastered on the gutted South End Armory prior to demolition is a poster urging a Democratic vote. Certainly, any South End residents "fed up" with the destruction of their homes and businesses would be likely to vote against William Callahan's fellow Democrat Bill Foley. Republican Gov. John Volpe strongly advocated building a freeway terminating in Allston—and leaving the South End unscathed.

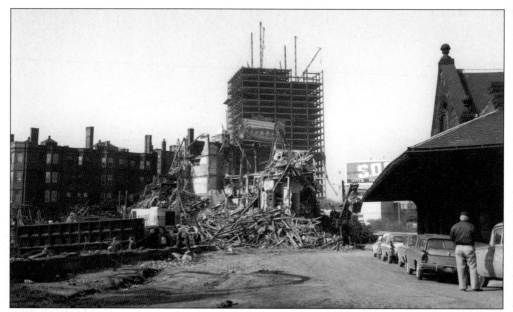

With the Huntington Avenue station to the right, the South End Armory comes down in the winter of 1962. The largest single structure demolished to make way for the turnpike, the South End Armory had been completed in 1890. It was one of the first armories constructed in Boston by the Massachusetts Armory Commission, founded in 1888. (Courtesy Perini Corporation.)

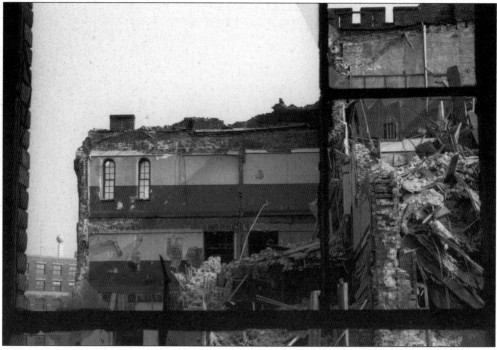

Through a shattered armory window, evidence of the old building's ornate headhouse parapet is visible to the upper right. After the demolition of the South End Armory, the Commonwealth Avenue Armory remained the city's only example of this type of structure. It and the smaller First Corps Armory on Arlington Street still stand today. (Courtesy Perini Corporation.)

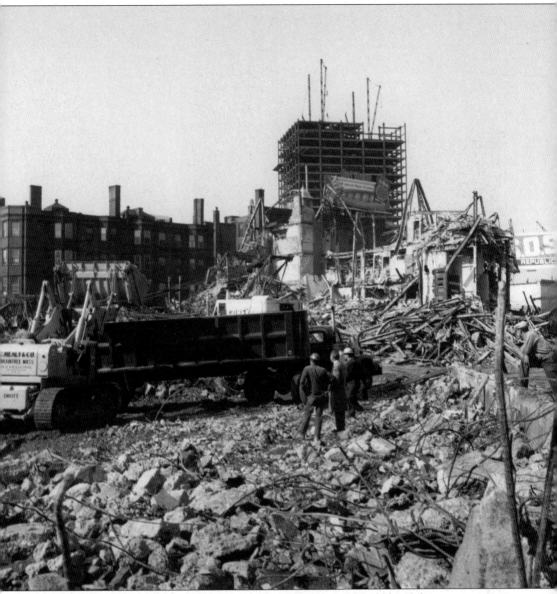

As the Prudential tower rises above the old city, a bulldozer loads rubble of the armory into a waiting dump truck. To the far right is a leftover billboard from John Volpe's failed 1962 gubernatorial bid. Volpe's campaign slogan—S.O.S. (Save Our State)—must have resonated especially well with those who lived or worked along the turnpike corridor.

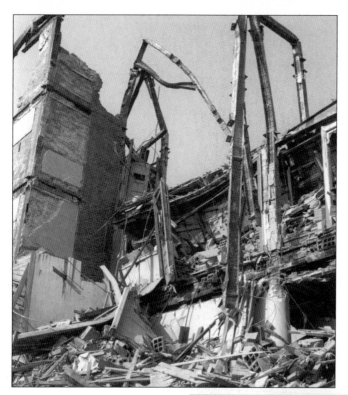

This view shows the *c.* 1890 steel-and-masonry skeleton of the South End Armory during demolition. This scene would be repeated hundreds of times by the end of the decade, due to turnpike construction and the urban renewal plans of the Boston Redevelopment Authority in other parts of the South End. (Courtesy Perini Corporation.)

The brick facade of the armory's headhouse crumbles during demolition. The armory's construction predated the widespread use of concrete-block walls. The building's solid brick walls are visible to the upper left. (Courtesy Perini Corporation.)

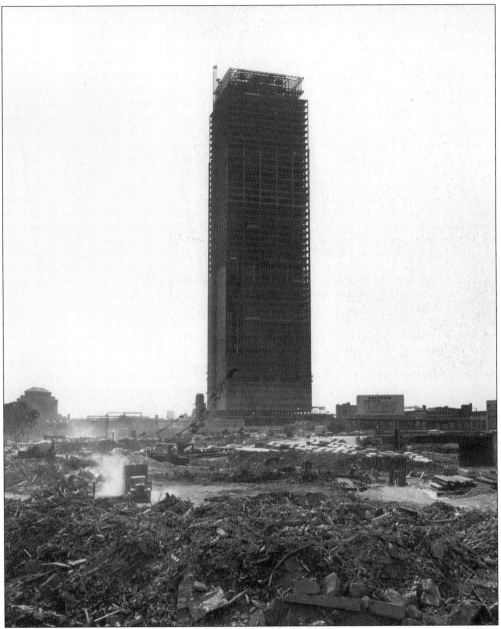

In the summer of 1963, the Prudential Center rises above the recent site of the South End Armory and future site of the Huntington Avenue interchange. This scene beautifully captures the essence of the "New Boston" ushered in by Mayor Johnny Hynes in the 1950s. Beginning with the construction of the Central Artery, for 15 years the city bore witness to a series of grandiose redevelopment and public works plans such as the two pictured here.

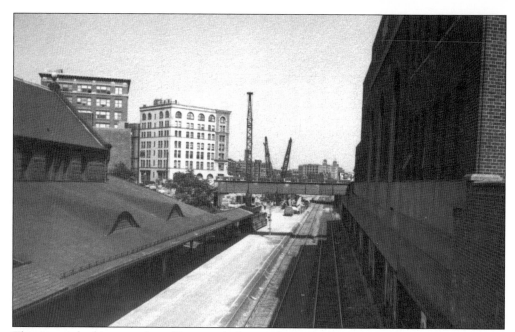

This image, looking east from Dartmouth Street, shows the Boston & Albany's Trinity Place station (left) and the Back Bay station (right). The Trinity Place station had only months before being demolished, and the Back Bay station survived another two decades before being replaced in 1986 with a modern structure as part of the MBTA Southwest Corridor project.

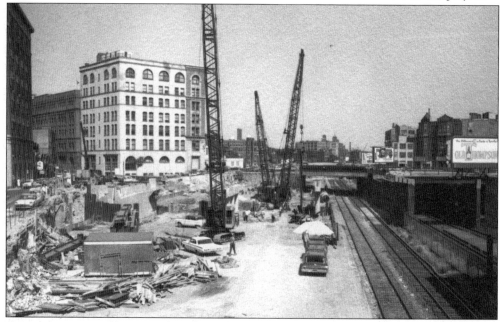

A trio of cranes works to complete the new Clarendon Street bridge in the spring of 1963. Of the 11 major traffic bridges between the Prudential development and the Central Artery, four (Huntington Avenue, Clarendon Street, Berkeley Street, and Washington Street) were rebuilt early in the construction process in 1963. Once these were completed, traffic was detoured onto the new bridges while the remainder of the bridges were closed and rebuilt.

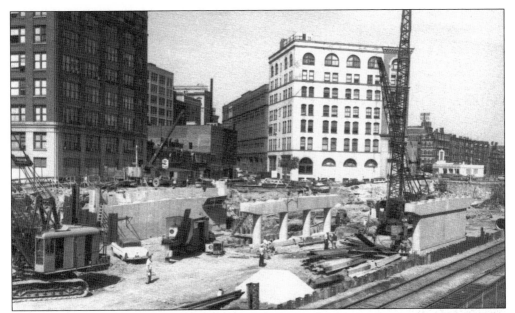

Taken in the summer of 1963, this photograph looks northeast over the reconstruction of the Clarendon Street bridge. The Pope Building, built in 1897, sits at the corner of Columbus Avenue (far right). Steel sheet piles have been driven deep into the ground along the operational New Haven Railroad tracks to avoid undermining the rail bed during work on the foundations of the new concrete bridge.

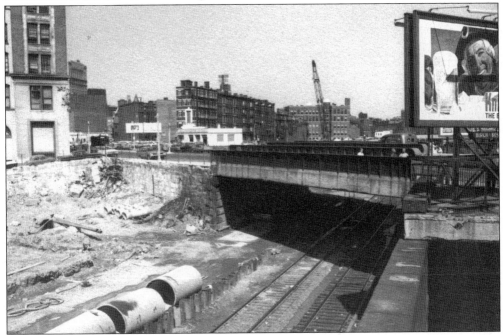

This view looks east over the Columbus Avenue bridge in the spring of 1963. The large concrete-pipe sections to the lower left would soon become the trunk of the turnpike's stormwater drainage system, running under the highway's median and collecting runoff from catch basins positioned along the road's curbside gutters.

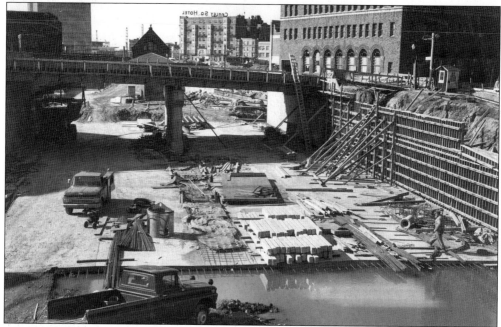

Pictured in the fall of 1963, this part of the city had once been marshy tidelands and maintained a high water table after being filled in the 1860s. Many buildings adjacent to the turnpike sat on wooden piles whose integrity depended on continued immersion. Turnpike engineers built the roadway inside a waterproofed concrete "boat" (shown here) that maintained the existing water table but kept the roadway dry and with a solid footing.

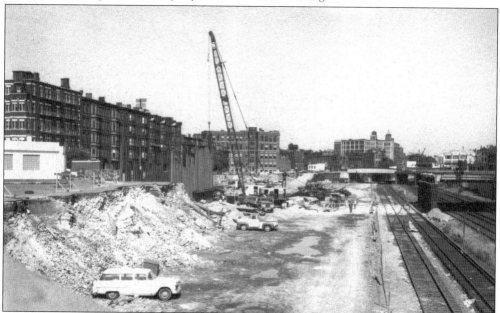

In the spring of 1963, the old Berkeley Street bridge has been dismantled and preparations are under way for laying the foundations of its replacement. The block of apartment buildings along Cortes Street (left) once faced similar structures across the road. Those buildings, however, were brought down in the fall of 1962.

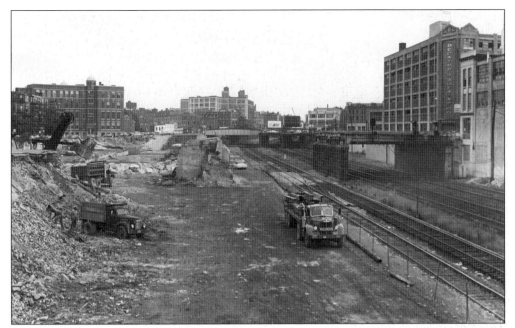

In this view (looking east from Columbus Avenue in the summer of 1963), the abutment of the old Berkeley Street bridge is visible at the center, marking the original width of the railway corridor. To the left, a power shovel whittles away at the fill placed a century earlier to widen the cut to its final dimension.

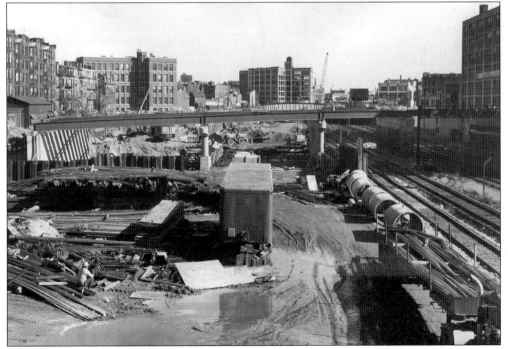

In a similar view four months later, the new Berkeley Street bridge is taking shape over a mud-filled trench not yet filled with the concrete boat section. At the far end of Cortes Street (left) is the Lincoln School building, completed in 1911.

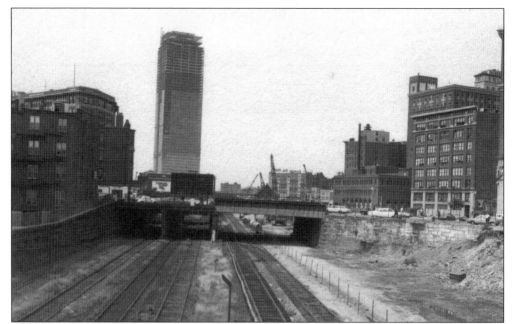

This photograph, looking west from the Berkeley Street bridge, shows the four tracks of the New Haven Railroad alongside the Boston & Albany corridor passing under Columbus Avenue. To the right is the Publisher's Building, built in 1922.

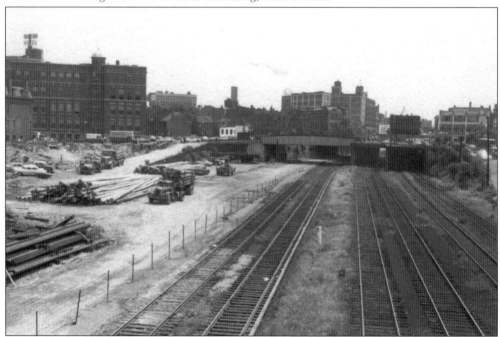

Looking east from the remains of the old Berkeley Street bridge in the spring of 1963, this image shows the Tremont Street bridge in the center. To the left is a future westbound entry ramp located at the corner of Arlington and Tremont Streets in front of the Lincoln School. Peaked-roof residential structures built in the mid-19th century are visible along Fayette Street near the top of the ramp.

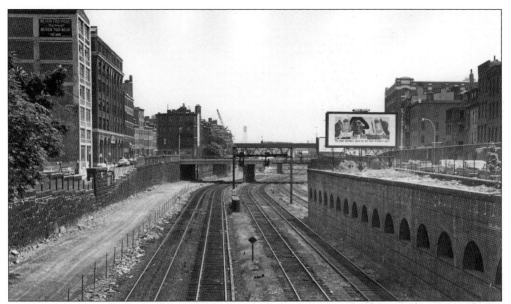

This view looks east from Tremont Street in the summer of 1963. The neighborhoods on either side of the railway corridor would soon experience dramatic and wrenching change. The turnpike right-of-way would plow through Bay Village (left) before the summer was out, and Ed Logue's Boston Redevelopment Authority had big plans for the Castle Square neighborhood (right). Starting in 1964, this neighborhood would be cleared as part of the authority's urban renewal program.

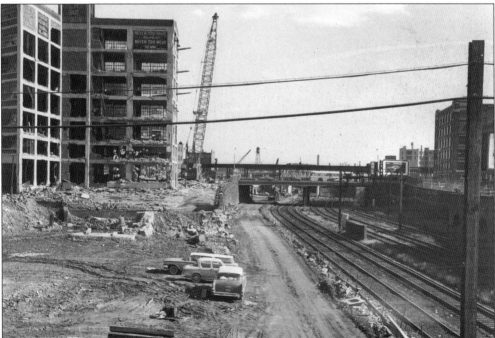

By the end of October, a similar view shows the demolition of the large industrial loft buildings along Corning Street. The cash-strapped city of Boston would lose nearly $16 million in taxable property as a result of the turnpike construction.

In January 1964, a worker chips away at the concrete bridge deck of the Tremont Street bridge with a pneumatic hammer. The posted 20-ton weight limit is somewhat alarming—many streetcars weighed 16 tons, and with four roadway lanes alongside the streetcar tracks, even light traffic could easily tip the scales.

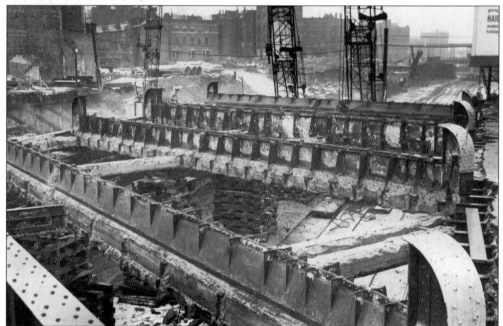

In February 1964, only the skeletal remains of the Tremont Street bridge still span the tracks. The concrete bridge deck, the steel stringer beams embedded in it, and the webs of the bridge's main steel support girders have all been removed to allow cranes to finish the job.

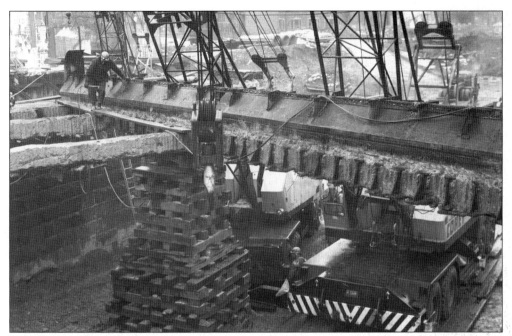

This dramatic view shows the final act in the demolition of the old Tremont Street bridge. A trio of cranes works together to lift one of the bridge's massive girders off temporary shoring blocks as a blowtorch-wielding worker severs the last of the permanent connections fixing the beam in place. This work took place on Saturday to minimize the impact on railway operations.

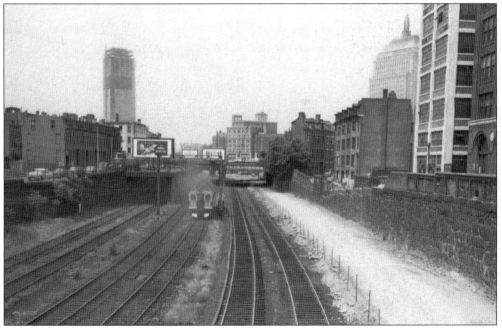

Farther east, a self-propelled Budd car of the New Haven railroad makes its way past Shawmut Avenue on its way toward the Back Bay station in the summer of 1963. The handsome row houses and larger commercial structures to the right along Corning Street were demolished only moths later.

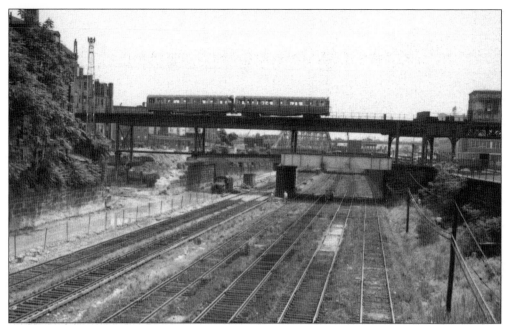

A Metropolitan Transit Authority elevated train passes over the Washington Street bridge in this 1963 view from Shawmut Avenue. The vehicular bridge is being demolished as part of the first phase of overpass reconstruction, with traffic detoured onto Harrison Avenue to the east.

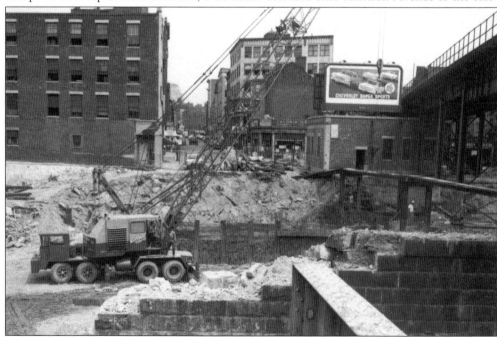

Pictured is a tricky crossing at Washington Street, where the Metropolitan Transit Authority's mainline elevated tracks pass over the turnpike right-of-way. Excavation is proceeding behind the old granite retaining wall of the railroad corridor where dense blocks of brick apartment buildings once stood along Corning and Ohio Streets. The four-story brick Noyes Building (left) later fronted on the newly laid-out Marginal Road.

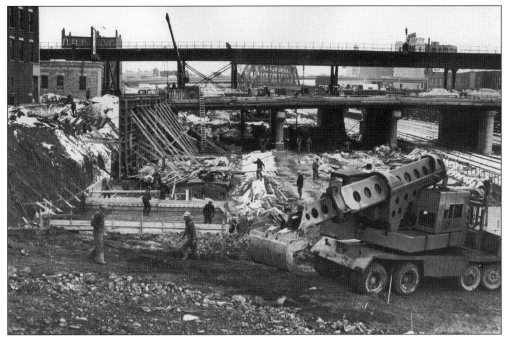

In this January 1964 view, the new Washington Street bridge is nearly complete. On the right, workers are forming part of the concrete boat section in which the finished roadway will be constructed.

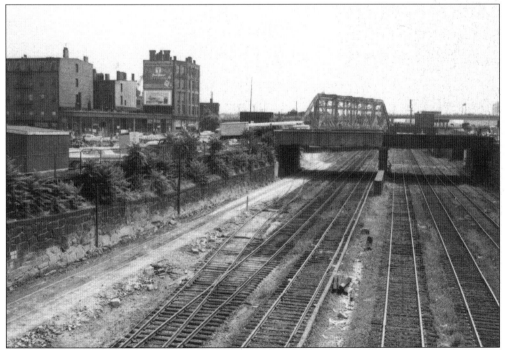

This view looks east from the Washington Street bridge in July 1963. To the left, the bustling corner of Harrison Avenue and Broadway has only a few months to stand before coming down to make way for the turnpike.

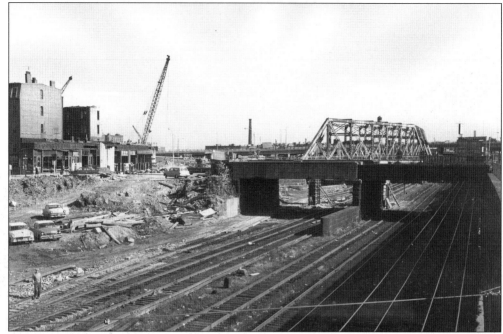

A view from the fall of 1963 shows the demolition in progress. The five-story building at 296 Broadway has already fallen victim to the wrecking ball, and the storefront that had previously housed Charles Mueller's barber supply shop is being gutted.

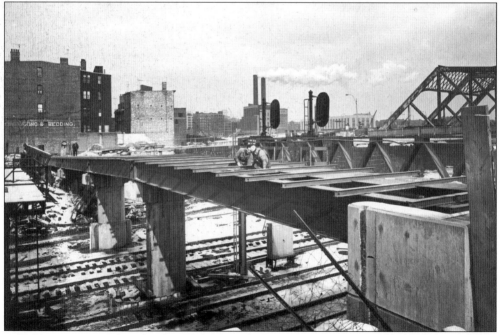

In order to accommodate the dense network of utility lines that spanned the turnpike, several dedicated utility bridges were constructed. In this photograph, taken in the winter of 1964, the Harrison Avenue utility span is taking shape and will soon support a large water line that once ran along the sidewalk of the old Harrison Avenue bridge.

112

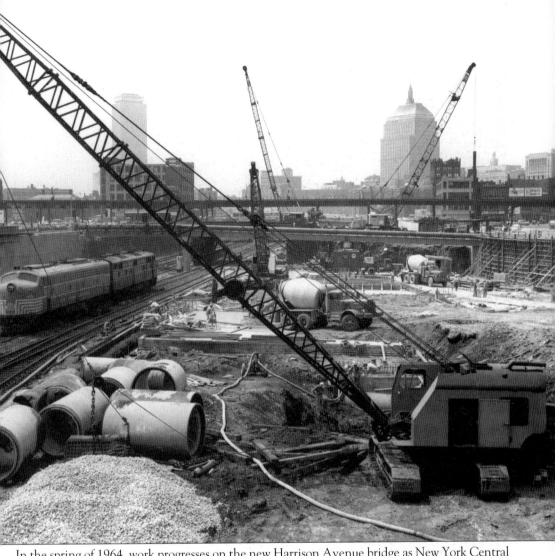

In the spring of 1964, work progresses on the new Harrison Avenue bridge as New York Central locomotives make their way west under the newly completed utility span. The collection of cranes is reminiscent of the current scene in parts of downtown playing host to the Central Artery/Third Harbor Tunnel project. (Courtesy Perini Corporation.)

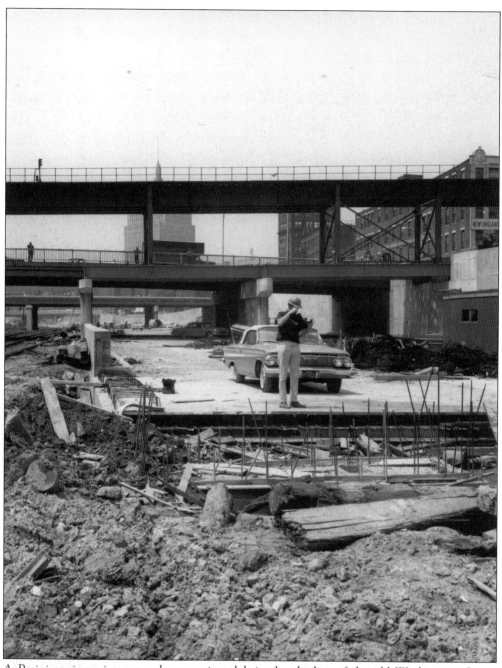

A Perini engineer inspects a boat section slab in the shadow of the old Washington Street elevated structure. The elevated ran slightly oblique to the Washington Street bridge at its northern end. A separate bridge structure (right), consisting of reinforced steel beams, was constructed alongside the new Washington Street bridge to carry the railway viaduct. (Courtesy Perini Corporation.)

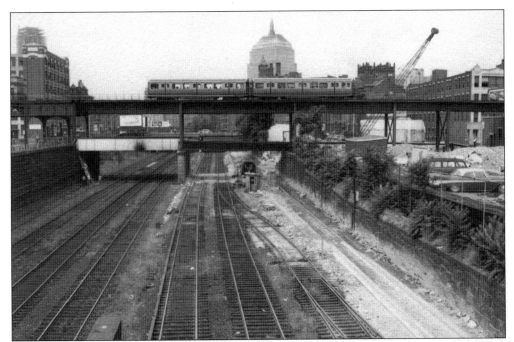

Two of the Metropolitan Transit Authority's new Pullman Standard elevated cars pass over the Washington Street bridge.

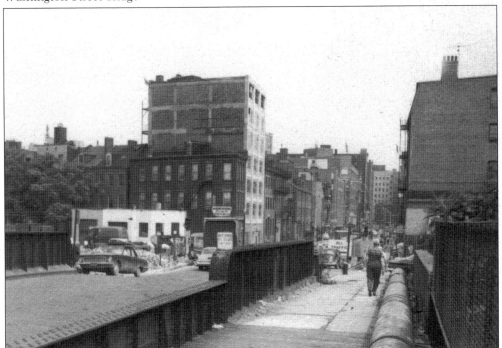

This view looks north along Harrison Avenue toward downtown in the summer of 1963. In 1912, local resident Mary Antin wrote that Harrison Avenue "is to the South End what Salem Street is to the North End. It is the heart of the South End ghetto. . . . Rarely as Harrison Avenue is caught asleep, even more rarely is it found clean."

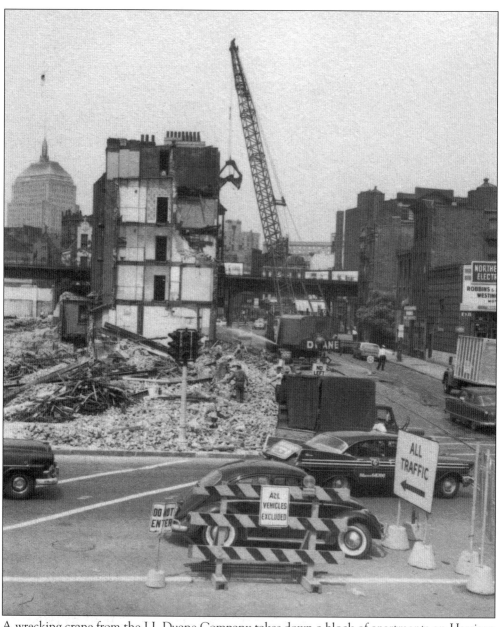

A wrecking crane from the J.J. Duane Company takes down a block of apartments on Harrison Avenue with the elevated railway viaduct in the background. The area around Harrison Avenue was home to many of the city's newest immigrants, especially after the demolition of the New York Streets area in the late 1950s. William Callahan met stiff political opposition to his turnpike extension plans from the residents of the western suburb of Newton, but in the dense neighborhoods like the one centered on Harrison Avenue, the residents' unfamiliarity with the political and legal systems afforded him an easy ride.

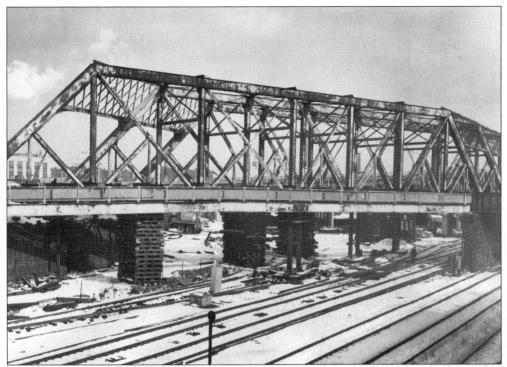

In late January 1964, stacks of railroad ties have been assembled to shore up the Broadway bridge deck while the trusses above are dismantled.

Sparks from a cutting torch fall through the skeletal remains of the Broadway bridge in February 1964. (Courtesy Perini Corporation.)

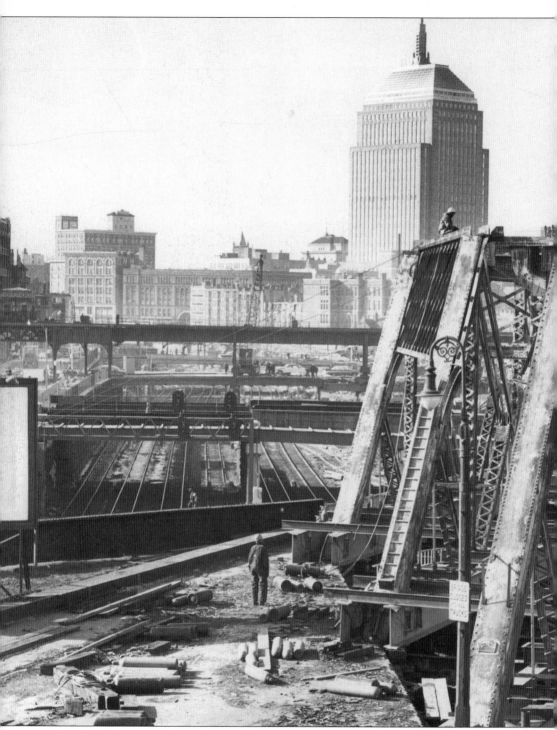

This fantastic photograph from February 1964 looks west over the remnants of the Broadway bridge from atop the new Albany Street bridge. To the left, the New Haven and the Boston & Albany corridors fade into the South End while the old John Hancock monopolizes the Back Bay skyline. To the right, the demolition along Harrison Avenue is complete. Albany Street

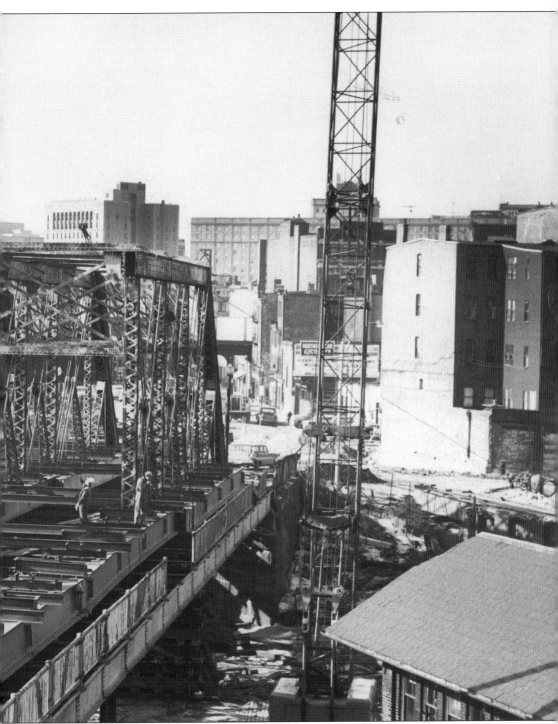

had also once traversed the rail corridor over a steel-truss bridge similar to the Broadway structure, but its abutments stood in the path of the turnpike's right-of-way and the bridge was replaced with a conventional steel-and-concrete structure in 1963.

This view looks east from beneath the Broadway bridge under the Central Artery in the summer of 1963. The old Albany Street bridge has been demolished. In the foreground, work is progressing on the new bridge's supports. Just beyond the Central Artery, the rail lines turn sharply to the left and enter South Station.

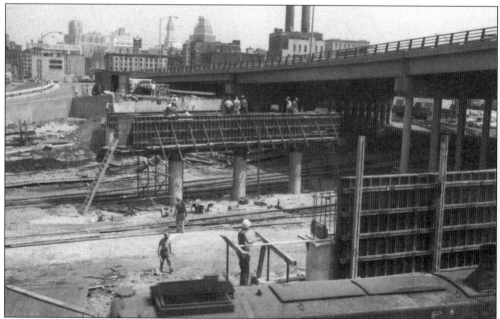

With Kneeland Street in the distance, workers form the concrete beams of the new Albany Street bridge as a locomotive idles in the foreground. Much of Boston's intercity passenger rail service had ceased by 1960, after the construction of the Southeast Expressway and the initial turnpike allowed motorists to make long-distance trips in their own cars conveniently and quickly.

120

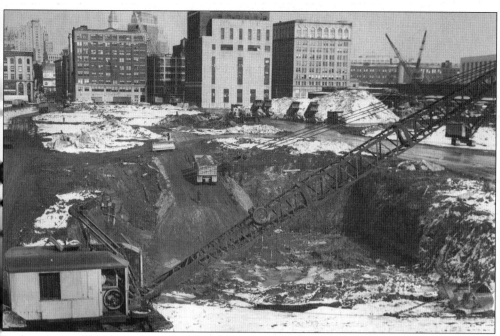

In the winter of 1964, on the site of the old Boston & Albany Freight House No. 1, a dredging crane is excavating soft fill that had been placed over a century before. In an unmistakable sign of the times, more than 10 acres of the Boston & Albany's downtown terminal facilities were cleared away to make room for the turnpike's interchange with the existing Central Artery.

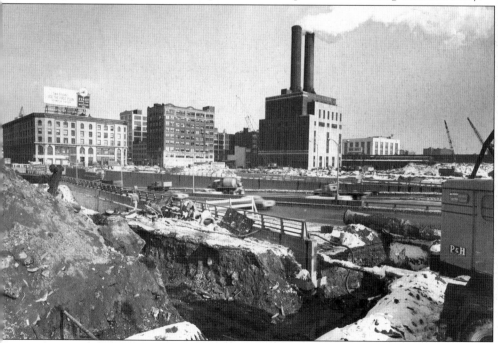

In the shadow of the Boston Edison Illuminating Company's steam plant on Kneeland Street, utility work is progressing alongside the southern portal of the Dewey Square Tunnel, completed in 1959.

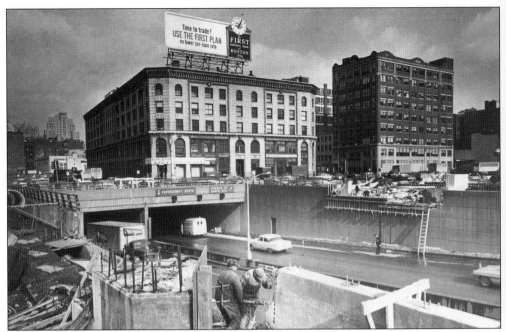

Workers prepare the abutments of an interchange bridge over the Central Artery just south of the tunnel portal. Tight to the wall of the northbound tunnel lanes is the handsome Albany Building, completed in 1900 and slated for demolition in early plans for the Central Artery's alignment.

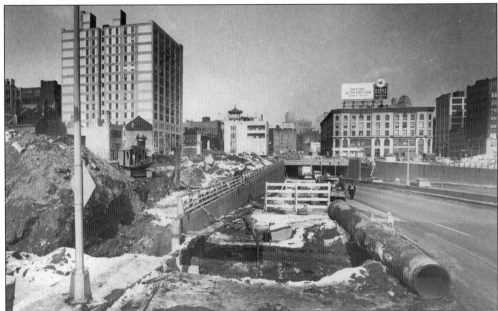

In January 1964, Albany Street (left) has been dug up for utility and foundation work. Anyone familiar with this view today will marvel at the lack of a downtown skyline. The top of downtown's most recent addition (the United Shoe Machinery Building, completed in 1930) is just visible over the cornice of the Albany Building (right). By the end of the decade, Boston's era of downtown stagnation would end in earnest.

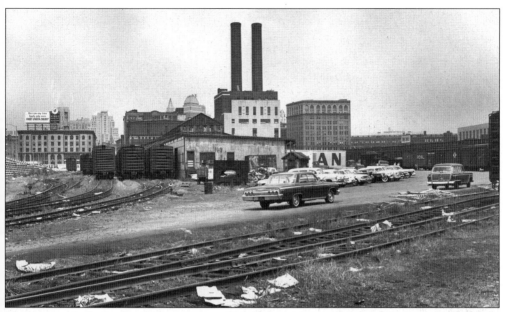

This rather bleak view from the summer of 1963 shows the condition of the Boston & Albany terminal facilities at South Station just prior to demolition. By 1960, only 11 Boston & Albany trains (passenger or freight) arrived at South Station each day, down from 65 trains 15 years earlier. When the Boston & Albany sold its facilities to the Turnpike Authority, the assessor's report found them "in generally poor condition."

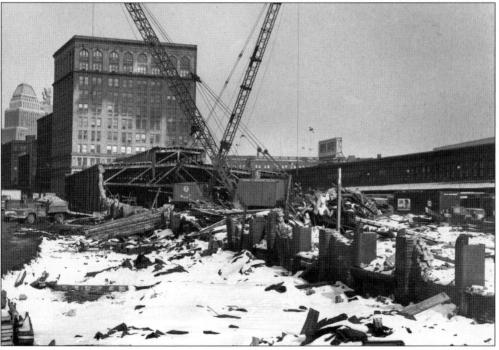

In the winter of 1964, the Boston & Albany Freight House No. 4 is being demolished to make way for a turnpike interchange ramp in front of the *c.* 1920 Pilgrim Building on Kneeland Street. The United Shoe Machinery Building is visible to the far left.

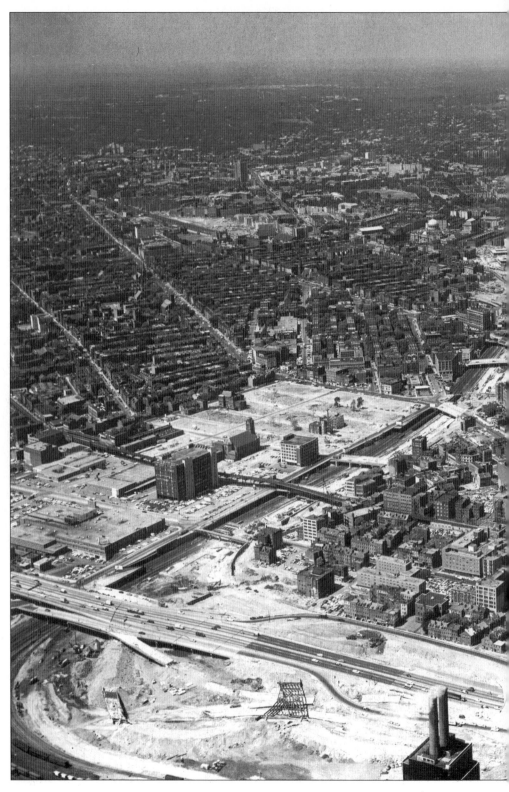

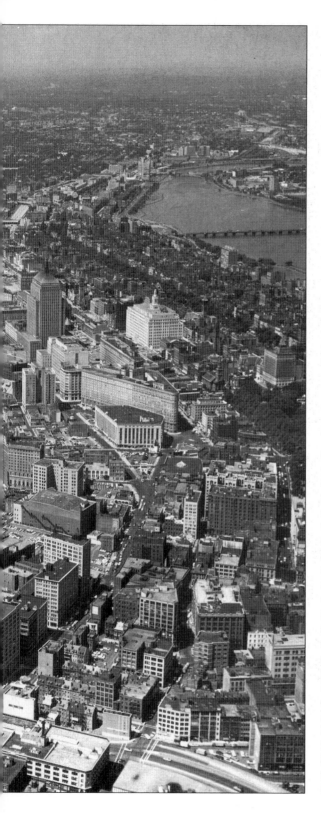

This fine view gives a good survey of the giant gash through the city created by the turnpike construction. Although the turnpike followed the alignment of an existing railroad right-of-way, the widening of the corridor reinforced the separation of many city neighborhoods and encouraged the continued flight of middle-class Bostonians to the western suburbs by affording them a convenient commute into downtown. This image also exemplifies the traditional attitudes of Boston planners and politicians of the day who favored large-scale renewal and development plans. From front to back are the Southeast Expressway/Central Artery; the turnpike extension; the New York Streets urban renewal area; and the Prudential development. (Courtesy Perini Corporation.)

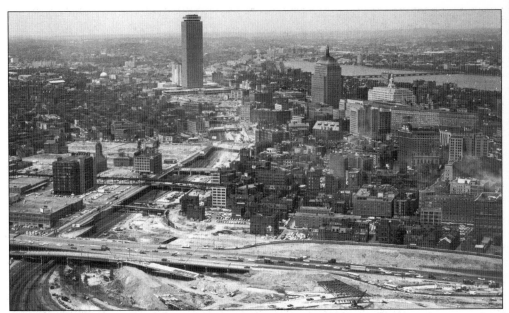

The massive turnpike interchange with the Central Artery is shown taking shape south of Kneeland Street in the summer of 1964. This image demonstrates the extent to which the newly completed Prudential building dominated the city's skyline. Less evident is the extent to which the new complex lent Boston renewed credibility as a viable market for high-rise commercial development.

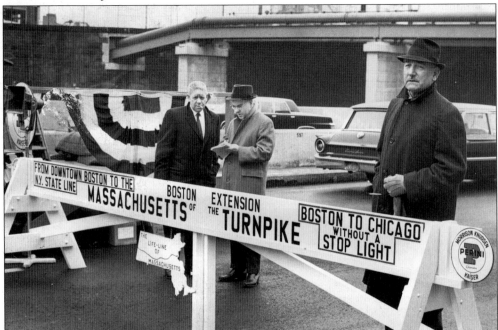

In this February 18, 1965 photograph, reporters survey the new road just prior to the opening ceremony. Although William Callahan died in April 1964, his dream of creating an economic lifeline of Massachusetts had finally been realized. At the top of the image is the completed utility span at Harrison Avenue. (Courtesy Perini Corporation.)

126

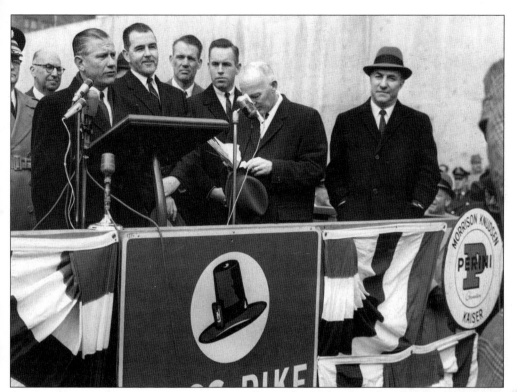

Among those at the opening ceremony are Gov. John Volpe (speaking); John T. Driscoll, Callahan's replacement as Turnpike Authority chairman (to the right of Volpe); and public works commissioner Francis Sargent (in the background to the right of Driscoll). (Courtesy Perini Corporation.)

The "New Boston" is shown in postcard form, with the Prudential tower soaring over the new expressway. Traffic in this view is unusually light, although drivers on the completed Boston extension would generally be spared the daily gridlock that plagues the city's other major in-town highway, the Central Artery.

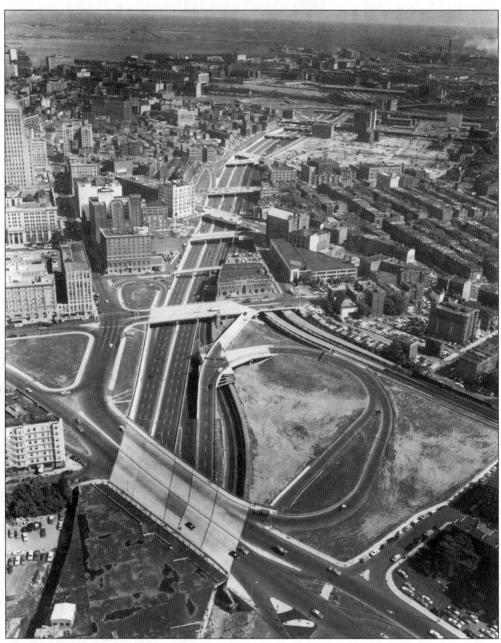

This view from the top of the Prudential Center dates from the summer of 1965 and looks east over the newly completed turnpike. In the foreground, the Huntington Avenue interchange occupies the former site of the South End Armory. New local street bridges crisscross the six-lane final stretch of the turnpike extension. The old Castle Square neighborhood (upper right) has been cleared to make way for a large housing development. This view would change dramatically beginning in 1969 with the construction of the Hancock parking garage over the turnpike next to the Back Bay station. It changed again in 1983, when the Copley Place development covered the Huntington Avenue interchange. (Courtesy Perini Corporation.)